ORGANIZING YOUR PHOTOGRAPHS

ORGANIZING YOUR PHOTOGRAPHS

Ernest H. Robl, *1946-*

AMPHOTO
An imprint of Watson-Guptill Publications
New York

Ernest H. Robl, a freelance photographer and writer, and editor of *Picture Sources 4*, a reference book for picture researchers, is a former UPI newsman and bureau manager, and was for ten years a cataloger and a supervisor of the Duke University Library Sytem. His specialty in the photography of railroads and railroad equipment has brought him international publication credits, and his illustrated "how-to" articles have appeared in *Technical Photography*, *Studio Photography*, and *Peterson's PhotoGraphic*.

Edited by Marisa Bulzone and Robin Simmen
Designed by Areta Buk
Graphic production by Ellen Greene

Copyright © 1986 by Ernest H. Robl

First published 1986 in New York by AMPHOTO,
an imprint of Watson-Guptill Publications,
a division of Billboard Publications, Inc.,
1515 Broadway, New York, NY 10036

Library of Congress Cataloging in Publication Data

Robl, Ernest H., 1946–
 Organizing your photographs.

 Bibliography: p. 181
 Includes index.
 1. Cataloging of pictures. 2. Libraries—Special
collections—Pictures. 3. Photographs—Conservation
and restoration. I. Title.
Z692.P5R6 1986 025.3'471 86–3654
ISBN 0–8174–5300–8
ISBN 0–8174–5301–6 (pbk.)

Manufactured in the United States of America

2 3 4 5 6 7 8 9/91 90 89

For those who've worked for me at Duke University's Perkins Library: I can only hope that along the way you've learned as much from me as I learned from you. Thanks.

Special thanks to KB and AHT for reading drafts of the chapters and offering helpful suggestions—and to CEF, who helped, too, even if unaware of doing so.

CONTENTS

PREFACE

This book is about taking a professional approach to organizing the photographs that you make or collect, whether for personal or business reasons—organizing them in such a way that you can find what you are looking for with a minimum of effort and at a minimum of expense.

It's about applying some principles that a lot of people spent a lot of time working out. It's about avoiding some of the pitfalls that others have already taken.

Broadly speaking, it's for librarians or anyone who manages a picture library—even if that library is a strictly personal one. Its starting point is designed for those with no library experience or formal study of librarianship, so it explains terms and practices that would already be familiar to an experienced librarian. However, it will be useful to librarians who are not visual media specialists.

Although this book is about taking a businesslike approach to solving problems and about applying principles, it doesn't prescribe a rigid approach. It isn't a book of rules, or even about librarianship itself; it's about being able to use your pictures—all your pictures—whether you just want to show them to a friend or whether you are filling a rush order for stock photos from a national publication.

INTRODUCTION

Why Organize, or Who Is This Fellow to Tell Me That

The slides from the brief trip to Europe were completely up to expectation, and, with much agonizing, more than two dozen rolls had been edited down to one truly sparkling 140-slide tray. The small group of friends at the party last night had been suitably impressed.

This morning, however, Harry called and said he would be making an unexpected business trip to Vienna; could you give him some tips on what to see and do there? Sure, you said, asking him to stop by for a quick audiovisual presentation on the city. In less than half an hour, you pull together another 140 tray, using not only a few of the slides from the previous night but also others from four previous trips, even adding a few copy slides of maps. As with all your slide shows, you open with your trademark title slide and close with a slide of your signature.

As soon as Harry leaves, you again dump the tray and begin pulling together slides for two portfolio presentations scheduled the next day—one for a corporate public relations director, the other for an editor of a trade publication. In each case, most of what you'll show will be heavily tailored towards the types of images each of the potential clients uses, but will also include a small sampling of travel, portrait and arty photos—just to remind them of your versatility.

Though potentially thousands of dollars in sales could result from each of the interviews, the presentations require only a few minutes to assemble. Four of the images in each of the presentations will be the same; the slides will be switched from one tray to another between appointments. There's nothing unusual about these various slide programs, except for an overlap of one or two images—the rest are pulled from a transparency file running in the tens of thousands.

As you are on your way out the door the next morning, the phone rings, and, when you pick it up, there's a picture researcher on the line asking about the availability of one of your photos she saw in a magazine. A glance at the file shows that the transparency in question was in a batch sent to the lab for duplication, but it should be back within the next few days. You tell the researcher as much and jot down a note to put the transparency back in the mail as soon as it arrives. The delay took only a few seconds, virtually assured a sale from the stock file, and didn't even make you late for your first appointment.

This admittedly contrived but nevertheless quite plausible scenario illustrates the value of having a properly organized photographic library. Perhaps you've never thought of your collection of slides, prints, and negatives, scattered through a dozen or so projector trays, file drawers, and even shoe boxes as a library. Most photographers don't realize how much they really have in common with librarians.

Think about it for a minute. A library consists of a collection of information and the people who service that information. Its major functions— perhaps all done by one person in a small library or by departments of dozens of people in a large one—are acquisition, organization, and circulation. In some cases, a separate function called collection development may be set up as a special aspect of acquisition. A major part of the organization function is usually referred to as cataloging.

Libraries are most often thought of in terms of books, but if you think of the same concepts in terms of photographic images, the parallels become evident.

This book is about taking a library approach to the management of your photographs, all the way from thinking of them as a collection rather than a file, to circulation controls—being able to keep track of what's where. A major portion is devoted to cataloging.

It's not a definitive book about libraries or even cataloging, though you'll probably learn a little about both and may even pick up some tips on getting more out of your local public or academic library. This book is only an introduction to the ways you can adapt techniques and approaches used by librarians to the management of your collection, regardless of whether you are a freelance photographer, advanced amateur, or simply need to maintain a photographic collection for some other reason.

"So, what's the big deal?" you may ask. "He's just going to suggest setting up a card file." Maybe you've never encountered some of the pitfalls of that simple "card file." Maybe you've never tried such a system because you think it takes too much time. But then, how much time have you wasted looking for pictures lately? How much money in potential sales have you lost because you weren't able to pull out images on an instant's notice?

Maybe you've already begun your own indexing and filing system. Perhaps right now it's working reasonably well because the file is still relatively small and you're the only one filing into it and having to retrieve from it. But do you remember how you indexed that photo of Uncle Charlie's dog? Or, what about that great scenic made from a moving train out in the middle of nowhere? As your business grows, you're sure to reach the point where you'll want someone else to be able to file and retrieve images with high reliability. Could you teach your "system" to someone else?

Check out some of the standard reference books used by picture researchers working for major periodicals and book publishers. One example of these is *Picture Sources*, published by the Picture Division of the Special Libraries Association (4th ed., 1983). A prominent part of each listing for individual and institutional collections is the availability of a card catalog. A researcher working on finding illustrations for a complex project

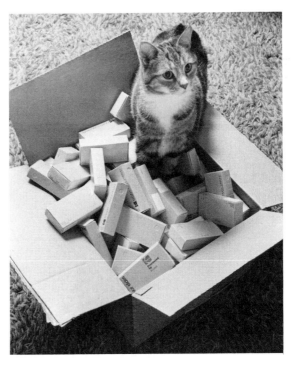

Does your slide collection look like this? Then this is where you'll start to organize it. Important considerations will include your choice of storage equipment and how you arrange photographic material within those containers.

may be able to work most effectively by searching directly in your catalog, thereby devoting far more time to his or her search than you could. But could this researcher make heads or tails of your filing system?

Don't think that just because you live in some small town, away from the major publishing centers, no researcher is ever going to show up at your door. The picture researchers with whom I've talked tell me that the trend is towards doing research where the subject matter is. For instance, the most economical approach to meeting tight deadlines on a textbook on North Carolina history may well be to send a researcher to North Carolina for a week. Major publishers are decentralizing their research staffs, such as Harcourt Brace Jovanovich which now has staff picture researchers based on both the east and west coasts.

However, a card catalog might not necessarily be the best or most efficient approach to your particular collection of photographic images.

If you are looking for a detailed blueprint to follow, chances are you won't find it here. What you will find is an examination of options and factors that weighs their costs in terms of time and money versus their benefits. Scattered along the way you'll find tips on how to take shortcuts and on problems to avoid. Library management consists largely of two things— common sense and following some established standards and conventions.

Why follow someone else's conventions? Perhaps for the same reason why motorists themselves don't choose whether to drive on the right or left side of the road. Either side works fine as long as everyone in the country agrees on the same option. A "communication problem" is a mild description of what happens when everyone doesn't.

The more closely you follow established cataloging standards, the better are your chances that you and a picture researcher representing a potential client or you and a cataloger working for you can talk the same language.

At this point, you are probably asking, "So, who is this fellow, that he thinks he can give me advice on how to organize my collection?" My qualifications include a decade of work in the cataloging department of a major university library, as well as my work as a freelance photographer, which has produced a steadily growing file of transparencies. I've worked on library planning committees and, as a supervisor, taught the basics of cataloging to new staff members.

Now, I'll admit to you right off that I use some non-standard cataloging for my personal collection. But my deviations from the generally accepted American cataloging standards were made intentionally for major time-and-cost savings and to fit the special features of my collection. Bring me someone well-versed in library practice, and I'll need less than five minutes to explain these adaptations. After that, he or she shouldn't have any trouble finding his or her way through my catalog.

Since this book is intended primarily as an introduction, we'll also take a look at other sources of library expertise. As with most things, you can either buy it—or steal it. This project would never have gotten started if there had been anything comprehensive in print on managing photographic libraries—something that was understandable to someone who does not already have a degree in library science. There are, however, some reference works which can prove invaluable even to a beginner to the field. If your collection and problems are large enough, you can also hire a full-time librarian, preferably with a specialization in audio-visual materials, to manage your collection; or, you can rent the services of a freelance librarian to help you plan the basic organization of your picture library and give you periodic advice, much the way an accountant sets up financial books and assists with special problems later on. In the long run, many commercial photo operations or firms with large photographic files find one of the above courses advisable.

A freelance librarian's services may be particularly worth considering. A fairly recent development in the library field, freelance librarians—often with a particular subject expertise—specialize in helping businesses solve information management problems, in setting up business reference libraries, and the like.

Now, some of you are asking, "Why, if I can pay someone else to do the work, should I pay any attention to the rest of this book?"

Look at it this way. You can hire someone to design and build a house for you. But, would you hire him to do this without telling him what kind of house you wanted? A photographic library may need just as much customization as the design of a house. Just as you'll probably get a more suitable house if you understand some basic architectural and engineering concepts, you'll probably get a much more serviceable library if you Well, you get the picture.

More likely, you'll find that you can design and use a sophisticated and highly efficient photo filing and retrieval system once you have looked at a few basic principles.

And, you'll find that much of the expertise and information you need is free. You may be surprised to find that you already have some of it and don't know it—and that you can find most of the rest at your local library. Many of the reference books mentioned here are also stashed at a local library—though possibly not out front on a shelf, but back in some librarian's office. That is because these books are being used every day by the library staff, not because you can't look at them. The fact is, nobody else has ever asked for them.

You'll find that librarians, particularly those who work at jobs like cataloging—mostly out of the public eye—feel notoriously underappreciated.

Catch them at an off-peak time, and you'll be surprised at how happy they are to talk about library operations and cataloging. After all, most libraries are in the business of giving away information—any kind of information. (That's what I meant earlier by being able to "steal" information; I really wasn't suggesting that you try to rip off the library's books.)

At the very least, librarians will be glad to bring their copies of the *Library of Congress Subject Headings* and *Anglo-American Cataloging Rules* out of the back room for you to look at to decide about investing in your own copies. If you can show librarians that you've gone to the trouble of learning some of their terminology, you're likely to get an even more enthusiastic reception.

Leave your stereotype of librarians at home. You'll find that many modern librarians have degrees or at least several courses in computer programming and business management as well as one or more subject specialties.

And on the subject of library terminology: A few words which may be new to you will be helpful in discussing some of the concepts I'll bring up. Each is explained the first time around. In case you skim past that explanation or skip around or forget, there's a glossary at the end of the book, where you'll also find a bibliography of books mentioned in the text (as well as a few other helpful publications) and a listing of organizations that may have something useful to offer.

CATALOG DESIGN AND PRODUCTION

LIBRARIANSHIP:

AN OVERVIEW

Or, a Little Historical Perspective
Never Hurt Anyone

Ever since there have been libraries, there have been attempts to keep track of what was in them. Among archaeological finds of collections of early clay tablets were found other clay tablets—which listed the contents of that tablet collection. In the beginning, the indexing methods were rather crude and inflexible. According to some reports, one ancient library more than 2,000 years ago used the walls for a list of its contents. Now, engraving a list of your belongings on your walls may be fine for permanence, but it leaves something to be desired when you need to make changes in the list.

While the concept of having a catalog of stored information reaches far back, the card catalog that you've used at one time or another is a relatively recent development. Until the 19th century, most catalogs were kept in book form. By today's standards, they were still rather primitive. Most listed the contents of a particular library only by the authors; a few had cross-listings by titles.

Compiling these lists was no simple task, particularly for large and still growing collections. To try to get all listings in alphabetical order, individual titles were written on slips of paper which could then be sorted into proper sequence.

Unlike some of mankind's other great inventions, the card catalog cannot be claimed as the personal invention of any one individual. In many places

at once, it gradually became evident that the boxes filled with paper slips proved a much more logical system of keeping track of a collection than printed book catalogs which were already out of date by the time they were completed.

At first these records were kept in various formats, but gradually the (then) standard size of French postal cards, 7.5 x 12.5 cm (just slightly smaller than 3 x 5 inches) became the accepted standard.

By now, you're probably screaming that you bought this copy (at least I hope you paid for it) to learn about organizing pictures. To illustrate some of the considerations we'll use in determining the organization of our photo collection, it's easiest to start from the more familiar library of books and to examine some of the reasons behind its operations.

READING A CATALOG RECORD

The card catalog is the easiest place to start. You've used one—maybe many, many times—but did you ever think about how and why it works? Probably not. At least not any more than about any other tool you use in your daily life.

Let's begin by looking at an imaginary cataloging record that we might find in an imaginary catalog of an imaginary public library. It might look something like this:

```
025.1771   Robl, Ernest H., 1946-
R666            Organizing your photographs:
068        a complete guide to sorting,
1986       cataloging, and storing pictures
           / by Ernest H. Robl. -- New York,
           N.Y. : Amphoto. 1986
                x, 242 p. : ill. ; 26 cm.
                Bibliography: p. 230-235.
                Includes index.

                1. Photograph collections--
           Management. 2. Cataloging of
           pictures. I. Title.
                        O
```

This is a relatively simple record—and the use of the term catalog record rather than catalog card is very much intentional, because, as we'll see, catalog records can come in a variety of forms. Probably you've seen catalog records like this many times without ever thinking about their components—or what they do.

Starting at upper left, you'll find a four-line block of numbers and letters that is collectively known as a call number. This particular library uses

the Dewey Decimal Classification (DDC) system, but the type of system used is not nearly as important as the function of this block of numbers and letters: It is an address—nothing more. By consulting a floor plan of the library or otherwise getting directions, this call number will get you to a specific shelf location where you expect to find the item represented in the catalog record—in this case, a book by someone named Ernest H. Robl entitled "Organizing Your Photographs."

The record begins, on the first line, with a main entry. In simple terms, this represents who or what is chiefly responsible for the creation of the work represented in the record. In this case, it is a person, but with many items found in libraries, it could just as easily be an organization (a company, a government body, etc.) or even a meeting. Where none of the three classes above—person, organization, or meeting—can be determined to be chiefly responsible, the main entry may simply be the title.

The main entry is then followed by a descriptive paragraph that is essentially a transcription of information found on the title page of the book. The sequence of information follows an international standard (called the International Standard Bibliographic Description, or ISBD for short) which also prescribes specific punctuation to separate various parts of this information. Basically, the sequence is: Title : subtitle / statement of responsibility.—Place of publication : publisher, and date of publication. This "description" helps us to distinguish this book from other books, or even from different editions of the same work, if any such exist.

The next paragraph—in this case consisting of a single line—tells us something about the physical characteristics of the book. This part of the record, called the collation, again provides information in a standard sequence according to ISBD: the number of pages (or volumes of a multi-volume work) : the fact that the book is illustrated ; and the height of the book.

Two more short paragraphs provide additional useful information—that the book has a bibliography and an index. These notes, which are called just that, can vary in number and contain quite a variety of information, depending on the work cataloged.

The final paragraph consists of what librarians call the tracings—a group of numbered items which "trace" the access points to be provided in the catalog.

Points of access? To understand this concept, let's look at what libraries do with a catalog record. If the library uses a card catalog, it reproduces the record on these cards. The plural—cards—is very important. In the case of our mythical record, the library would reproduce it on at least five cards.

The first of these cards would be filed in the catalog's alphabetical sequence under the main entry (Robl). Simple enough.

Three more of these cards are then (usually) overtyped with the tracings created by the cataloger. The cards would look something like this:

```
              Photograph Collections--
              Management

025.1771  Robl, Ernest H., 1946-
R666           Organizing your photo-
068       graphs : a complete guide to
1968      sorting, cataloging, and storing
          pictures / by Ernest H. Robl. --

                      O
```

and

```
              Cataloging of pictures

025.1771  Robl, Ernest H., 1946-
R666           Organizing your photo-
068       graphs : a complete guide to
1968      sorting, cataloging, and storing
          pictures / by Ernest H. Robl. --

                      O
```

and

```
              Organizing your photographs

025.1771  Robl, Ernest H., 1946-
R666           Organizing your photo-
068       graphs : a complete guide to
1968      sorting, cataloging, and storing
          pictures / by Ernest H. Robl. --

                      O
```

These additional cards are then filed alphabetically by the overtyped information—the two subject headings and the title. Counting the main entry, we now have four points of access to the work represented in the record. Someone looking for something by this author—anything by this author— would, by looking under Robl in the card catalog, find this record. Through its call number, the record would then lead the library patron to the shelf location. The same would work for someone knowing only the title. Someone looking for something on cataloging of pictures or photograph collections as general subjects would also be sent to the same "address" in the shelving area.

In brief, then, a catalog record is a bridge between one or more access points and an address where the item cataloged is expected to be found. The number of access points you need for any item can have a substantial impact on how you decide to store the items in that collection.

"So what?" you ask, having figured most of that out by now. "And, what happened to card number five?" The fifth card goes into a file called a shelflist, still another point of access.

THE SHELFLIST

A shelflist is simply a file set up in call number—or address—order. Almost all libraries have these files, but, since most of the shelflist's functions are internal management ones, the shelflist is often located away from public areas, accessible only to library staff members.

In our mythical library using the Dewey Decimal Classification system, someone knowing that 025.1 represents library management, could also look through the records in that shelflist sequence to see what the library had on that subject—something that could, of course, also be done by browsing through the shelves housing books with those classification numbers. But, what if the work isn't on the shelf? What if, between two books classified in 025 and 026, there's a gaping hole? The shelflist tells you what is supposed to be there.

With books, you will very seldom find any information on a cataloging record that you could not also obtain from a detailed examination of the book itself. The catalog is essentially a one-way tool to get the library user from an access point to the item he wants.

With photographs, quite the opposite is true. Unless a photograph was made with one of a few very expensive cameras designed to print a small amount of data on the film itself, there are usually going to be quite a few things that we may want to know about an image that may not be immediately apparent by looking at it: the names of the people pictured, the date the photograph was made, and the location, for example.

Therefore, it now becomes imperative that we have a reversible process that allows us to get not only from the access point to an image, but

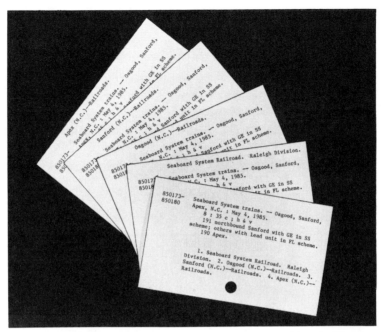

Set of catalog cards for a group of eight color slides. The shelflist card (which will file numerically) is on top, followed by cards overtyped with the subject headings included in the tracings at the bottom. Notes on the cards record descriptive information (such as train numbers, paint schemes of locomotives) in an abbreviated form that would make sense to someone familiar with the subjects.

also from an image back to the cataloging record. Remember the call number or address in the sample cataloging record at the beginning of this chapter.

It doesn't really matter what type of system is used to design this address; what does matter is that this address be unique to a particular item— and that that address be marked on the item (or its container). As long as this is true, and we then create a shelflist in call number or address order, we can then go from the item back to the cataloging record with the desired reversability.

For book libraries, the shelflist is used mainly for inventory purposes; in picture libraries, it can also serve a variety of other purposes. All of which brings us to some fundamental differences between the cataloging of books and images.

PICTURES VS. BOOKS

Cataloging of pictures is both simpler in some ways and more difficult in others than that of books because the latter have title pages. Many of the long and very complicated rules of cataloging deal with the proper form of transcription and interpretation of the almost infinite possibilities

of arrangement of information on the title pages, the verso (back) of title pages, covers, and colophons of books. Even most audio-visual materials that are mass-produced are more similar to books than to other collections of photographic images in this respect. Movies have title frames at the beginning to tell you something about who was responsible for their creation and something about their content. The same goes for filmstrips; even pre-packaged slide presentations come in a box with some type of label on it. They all have some type of words to give you a head start.

Most photographs, with the possible exception of portfolios sold as such, are not "published" in the normal sense of that word. (Here we're talking about photos as entities in and of themselves—not as they may appear reproduced in a book or magazine.) Published portfolios would normally be issued in some type of labeled container.

In a photo library, we are dealing with images that come into the collection without any labels—though we certainly have the option, as part of the organizing process, of adding labels with whatever information we choose. This means that whatever "description" we have in our word-cataloging records has to be supplied from interpretation of that image and—very important—from whatever information is available about the conditions and circumstances under which the image was created.

For a small collection, much of the work will be by one or at most a handful of individuals, so "authorship" is not going to be a very useful access point, and the pictures are not going to have any titles. You may want to make access points for individuals or corporations that commissioned the making of groups of images, since they do in effect have a share of the responsibility for the creation of those images. But ultimately, subject access is the key to your photographic library.

"So, why did he take up all this time and space to reach such an obvious conclusion?" you ask. Only to drive home the point that you may not find much useful information in some introductory books on cataloging or library organization since they are aimed basically at books. It's also why picture librarians and book librarians have so much trouble talking to each other. With more and more libraries now collecting and servicing non-book materials, the gap is closing.

THE CAPTION

Ask most buyers of (or simply users of) photographs what they value equally with image quality and content, and they will tell you: "The caption!" The quality of the caption can have more to do with whether or not a photo is published than the quality of the photograph itself.

Logically, then, the quality of your cataloging is going to be dependent on the information recorded at the time a photograph is made—information in addition to that recorded on the film itself. There's no need to keep

voluminous notes if you are reasonably familiar with the subject photographed, but a few words jotted down at the time of shooting can go a long way.

I carry with me a small pocket appointment calendar which has blocks about one by three inches for each day. In most cases, the three square inches suffice for my needs. I write down one or two words describing the subjects and locations of what I shot that day. That takes care of the what, where and when.

If you've ever had even the most basic of journalism courses, you'll have encountered the five Ws and an H that every story should cover: who, what, when, where, why and how. Those same six concepts also serve as a good foundation for consideration in organizing a photographic collection. In fact, they provide the kinds of access points that you may need to find a particular image.

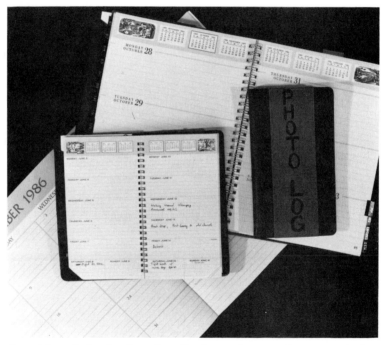

Organizing photos begins when they're made—sometimes even before they're made—by accumulating information about the subjects. Calendars of various sizes can be used to record what was photographed and where, for later reference. I use a pocket calendar (with a bright strip of colored tape on the cover to distinguish it from my appointment calendar) to log subjects photographed.

SELF-INDEXING FILES

An Image Can Be Its Own Access Point

Subject access is simple. All you need are some access points for each of the questions: who, what, when, where, why and how—or at least as many of them as may be applicable to a given picture. But how many subject access points? And what do you call a given subject? People are relatively simple to deal with; most of them have a name—and most of them keep the same name most of their lives. Things and abstract concepts are a bit more difficult.

For instance, several different words can mean the same thing; there are even more cases where terms mean nearly the same thing. There are broad terms covering larger areas and there are very specific terms. There are laymen's terms and technical or scientific terms for the same thing. Perhaps you own a thesaurus, such as one of the many editions of Roget's; it is only a small indication of the problem of synonyms.

As a small example: What is it that you have sitting in front of your door? Is it a car? An automobile? A motor vehicle? Sure, you can pick one of the terms. But even if you remember which term you used, would someone else be able to make the same choice?

Before we look at how to cope with these and other fun problems, let's take a look at what I'll call Ernest's first principle of cataloging:

Cataloging is always a compromise; the only perfect representation of the item cataloged is the item itself.

For organizing pictures, the pictures themselves can be access points. Depending on the nature of your collection, you may not need a "word" catalog at all, or may need it only for part of your collection.

THE CONTACT SHEET FILE

A contact sheet is a perfect access point. Most types of film already have frame numbers. Now, as long as the envelope containing the film and the contact sheet have the same unique identifying number, the combination of that number and the frame number provides a unique address. If you or someone else needs to find a particular picture, it's only a matter of looking through the contact sheets to find the image you want—the image which will lead you to the negative, which will get you to the print you want. It's the basic knee-bone-is-connected-to-the-thigh-bone system.

Of course, this system has some built-in problems, too. Depending on the total size of your collection, it may not be practical to look through all your contact sheets every time you want a particular image. And this system works best for negatives, although it is possible—though not cheap—to use it for transparencies. It is, in fact, the system used by some of the world's top stock photo agencies to offer clients a preliminary selection of transparencies. They use a color photocopier (Xerox machine) to make "contact sheets" which can be examined by the clients. This technique reproduces both the transparency image and whatever information is written or stamped on the transparency mounts, including identifying number or address where the transparency is stored in the files.

The image quality can only approximate that of the actual photograph, and color Xerox machines are somewhat outside the price range of an average individual and even most businesses. A local library, photoduplicator or instant printing service may, however, offer this type of copying on a fee-per-copy basis.

Despite its drawbacks, however, this system does have its advantages: it cuts down on handling of valuable originals; it allows many more images to be mailed for examination at a smaller expense; and it allows presentation of the same images to more than one potential client, without tying up the master image.

Some large custom color labs also offer a similar service using actual photographic reproduction of 20-slide plastic pages in "contact sheet" format, but you end up paying even more for the better images.

But, back to the contact sheets. Regardless of whether they are made from black-and-white or color negatives, or even color transparencies, you will sooner or later need to arrange them in some way that keeps you from having to look at each one every time you search for a particular image. This brings us to what librarians call a self-indexing file.

This simply means a file arranged by the labels on the contents—without an additional external index such as a card catalog. For example, you can put your contact sheets in file folders, ring-binders, or cardboard boxes. The container isn't important—but the arrangement is.

One possible arrangement is chronological: All the contact sheets from 1978 go into one folder, binder or whatever; those from 1979 into another, and so on. That way, if you know you want an image from a particular year, you need only look through the contacts for that year. This arrangement may be the most useful in news photography where the time a photograph was made is a key element—a date that can often be established from other sources.

The furthest extension of this idea is to go to a strictly chronological arrangement of your contact sheets. You can then, in the case of voluminous files, subdivide into months, weeks, or even days, making access to the images made at a desired time very rapid. Please note that I am only talking about the arrangement of the contact sheets; you can arrange the negative and/or slide files any way you want as long as the contact sheets contain some link to the correct address. This lets you make your negative/slide files into another self-indexing system, arranged by another scheme. You now have at least two points of access.

Another possibility is to arrange your contact sheets by some more or less sophisticated subject breakdown. Depending on the kinds of photos you make or collect, these could be "travel," "sports," "portraits," etc. In a corporate file these categories might be "company officials," "production," "product photos," etc. The contacts in these categories can be further sub-arranged by date, which considerably cuts down on the searching if you know both the category and the approximate date. Where there is an overlap of subject categories in a single take, the simple solution is to make two or more prints of the same contact sheet and file one copy under each category. In each case, the image itself is the access point.

THE NEGATIVE OR SLIDE FILE

The simplest version of the self-indexing concept is to forget about the contact sheets and simply make your negative or slide file self-indexing. In all probability, this is the type of arrangement that the vast majority of photographers use without really realizing what they are doing. In all probability, too, the arrangement is not the most useful one possible.

Among other things, it means a lot of handling of valuable original material, and each original item can only be in one place at one time.

The first tendency is to simply file negatives in chronological order. This creates a self-indexing file, if you at least write the date on the envelopes or sleeves. But, for many types of photography, date is not one of the most useful methods of access.

Negative files can be arranged in many ways, but using looseleaf transparent pages allows a variety of formats to be stored in the same file—such as the 2¼"-square and 35mm negatives shown here. If these pages are stored in ring binders (adapters are available for also hanging them in suspension-filing drawers) then the binders should be stored in slipcases or other enclosures to keep out dust.

For a portrait studio, a more functional arrangement may be by family name, subfiled by date. In this case, the file will grow throughout rather than just at the end, but this can be taken care of by either leaving room for expansion throughout from the beginning or by doing some occasional shifting.

The basic problem with a self-indexing file without some external access (such as contact sheets, a card catalog, etc.)—regardless of whether this file is arranged in direct order (simple chronological) or hierarchical (family name subdivided by date)—is that it only offers a one-dimensional access to its contents. If our portrait studio, using either one of these arrangements, wanted to pull sample groups of portraits of young children or elderly couples for a sales display, this would be impossible without knowing when the photos were made or the family name.

All of which brings us to my second principle of picture organization:

No single solution is applicable to all problems or all types of situations.

Take a careful look at a local library, and you'll probably find that while its main book collection is indexed in a card catalog with multiple access points, it has at least some collections that are not listed in the catalog but simply arranged in some type of self-indexing arrangement. A common example is a collection of out-of-town telephone directories simply arranged

27

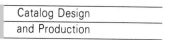

in alphabetical order, either strictly by city name or first by state and then subfiled by city. Which brings us to a couple more of my principles:

Cataloging of any collection is expensive. The more complete the cataloging, the more expensive it is.

It makes sense to use the cheapest solution that will achieve the desired goals (in other words, which provides adequate access to the materials in a particular collection).

For the above reasons, it generally makes sense to subdivide large collections into parts which can receive different treatment in arranging and indexing.

Unfortunately, sometimes the only solution that provides adequate access is a costly and complex one. The question of what is indeed adequate can only be answered by the manager or users of a particular collection.

My own photo collection currently consists of two self-indexing negative files (basically chronological), some self-indexing print files, and a large (20,000+) transparency file with fairly sophisticated subject cataloging.

And, just so that you don't go into cataloging land with any illusions, here's one final bit of information: Most libraries spend at least as much as the purchase price of an average book on processing (including cataloging) of that book. With the price of many trade books—even those without illustrations—running upwards of $20, cataloging is expensive.

Yet full cataloging of photographs is even more expensive and time consuming than cataloging books, because books are produced in printings of anywhere from a few dozen to hundreds of thousands of copies. Once one of these identical copies is cataloged completely—or at least as completely as the prevailing standards specify—that cataloging is good for any other copy of the same edition. International computer networks then allow libraries to access that cataloging for their individual purposes.

Obviously most pictures are unique items, and therefore each one requires original cataloging.

THE LIBRARY OF CONGRESS SUBJECT HEADING SYSTEM

A Rose by Any Other Name Is a Problem

Since we have established that subject analysis is the only practical method of providing access to photo collections, let's now focus on the structure of subject headings. What are "subject headings"? They are words or phrases that we use to represent a particular subject in our catalog.

We need to consider the problem that librarians call "authority." In this particular case, authority has nothing to do with being able to tell your employees what to do. To librarians, authority has to do with what you call something—or rather, whose word you take for what to call something. At the beginning of the last chapter we saw the problems posed by the multitude of different names something can be called, exemplified only in part by the well-known thesaurus. The answer is to use some type of subject heading system.

The Library of Congress Subject Heading System (commonly referred to as LCSH in library literature) is the most widely available general-purpose subject heading system for use with manual files. It's qualifications—widely available, general-purpose and for manual files—are worth stressing, because LCSH has many faults, not the least of which is that it tries to be all things to all people. Moreover, it is designed primarily for books.

Fundamentally, LCSH is a thesaurus, too. Among equivalent terms, LCSH specifies the form to be used. LCSH answers the question about

choosing between the terms "cars" and "automobiles" by specifying "automobiles."

Of course, no thesaurus, not even one as weighty as the massive LCSH books (2,500+ pages in two large-format volumes in the 9th edition) can cover all possible terminology, let alone include a list of all possible names of people and organizations. So, the Library of Congress Subject Heading System consists of two major components: the first consists of a continually updated list; the second part is a set of rules on how to "set up" headings for those items not on the list.

Under the LCSH system, subject headings are divided into two main groups: topical headings and name headings. Topical headings are those for groups or categories of things or concepts. Name headings are those for individual people, places, organizations and meetings. In library terminology, these are called personal name, geographic, corporate and conference headings.

Topical headings are the ones found on the LCSH list; the name subject headings are those for which there are rules, either in the LCSH books themselves or the Anglo-American Cataloging Rules (AACR). The currently-used second edition of AACR is generally cited as AACR2.

When the entire system is used, theoretically any two catalogers anywhere, in determining that a particular item (whether book or picture) covers or depicts a particular subject, should both be able to assign it the same subject heading, which brings a certain amount of predictability to the user as well as the cataloger.

It's a two-step process: first you determine the subject(s) depicted, and then you find the term to represent that subject. A subject heading system helps you with the second part, but the first part is still up to the cataloger's interpretation and judgment.

Providing multiple access points increases the chances of getting the potential user together with the item or types of items he is looking for. With pictures, the cataloger has to have at least some idea of what he is looking at before he can begin to think about what the proper form of the subject access point(s) should be.

On first looking at the LCSH list, the initial reaction of someone interested in organizing pictures is likely to be, "This won't be of much use to me." There are headings such as "Philosophy," "Literature," and "Theology," and many more which aren't really the things you go out and make photographs of every day. That was my initial reaction, too, when I decided I needed better access to my slides—and this was after I had been working with LCSH for several years in cataloging books. Yet, as my catalog has grown, I've found that the basic system is serving quite

well. I've made a few adaptations in special areas, but these are the exception rather than the rule. We'll look at some of these later on.

It is rather difficult to talk about how this system works without being able to look at it. LCSH is a basic reference tool, and you should be able to find it at virtually any library, large or small, though you may have to ask for it.

LCSH is available in two forms: as printed books and on 4 x 6 inch microfiche (48x reduction). As of this writing, the latest book edition is the 9th, published in 1980 and representing the status of LCSH as of 1978. There are annual quarterly and weekly supplements available, but there are few collections that really need those. The fiche version is published quarterly, with each set of fiche completely replacing the previous one. Thanks to computer-assisted production techniques, you get a brand new list four times a year. Both editions have advantages and disadvantages.

The book edition is enormously bulky and requires you to look in several supplements to be sure you are using the latest version of a subject heading. On the other hand, since it is printed on paper, it can be annotated, and those particular areas where you choose to depart from LC practice can easily be indicated. The latter can be quite important, since most libraries specializing in a very narrow subject area find that LCSH does not offer enough specificity in that subject. It is, after all, a general purpose subject heading system.

The fiche edition offers both compactness and quicker access to the latest version of a subject heading. It cannot be annotated, however, and does require a special "reader" or viewer. That latter disadvantage is partly offset by the fact that more and more technical information is now being published directly in microform. Also, fiche readers are now becoming cheaper and more common, particularly for businesses. (Many types of photographic enlargers will also do as a make-shift fiche reader in a pinch.)

If all this weren't enough, the Library of Congress also publishes a periodical called *Cataloging Service Bulletin* (CSBs, in the initialism-happy library world), a substantial part of which is devoted to LC subject cataloging policies, changes in the applicability of specific subject headings, and explanations of the scope of particular headings.

In 1984, LC made available its own *Subject Cataloging Manual* in loose leaf form. It consists of some 500 pages of internal memos on how to assign subject headings in various subject areas. The manual comes with a detailed table of contents and index and provides many useful hints in applying LCSH.

Before deciding that you are now not only in over your head, but already going down for the third time, bear with me for a few more lines.

First, the question, "Why all these changes requiring supplements and revisions?" Language and terminology do change. And a surprising number

of new things are constantly being discovered, invented, or otherwise being foisted upon the unsuspecting public. A major part of the changes in LCSH between 1974 and 1976 were in terms that were once found "acceptable" but which are today considered either sexist or racist. Still others were simply changes where one term had found greater public acceptance than the one first assigned. For example: "Flying saucers" has been replaced with the heading "Unidentified flying objects."

Some new subject headings are added for events which have just occurred and which people are now writing books about. Examples:

> Falkland Islands War, 1982.
> Korean Air Lines Incident, 1983.
> Iraqi-Iranian Conflict, 1980–

Despite all this, however, the basic structure of the system remains much the same. And, unless you are cataloging either mostly news photos or illustrations in a quickly-changing scientific area, you may well be able to get along just fine with a slightly outdated copy of LCSH.

ACQUIRING THE LCSH

You may be able to pick up a second-hand copy of LCSH for nothing. I began cataloging my own collection using fiche editions discarded by a local library when they were superseded by newer ones. Still, the basic prices are still quite a bargain. The giant 9th edition (book form) goes for $75. That may still sound steep, but look at what you're getting— and in most cases it'll be a deductable business expense. And you couldn't produce something like this yourself by investing several hundred times this amount.

The annual subscription for the printed quarterly supplements, which aren't essential, runs $65. A year's CSB subscription of four issues is $18, but goes down drastically if more than one copy is shipped to the same address—so you may be able to buy it jointly with others and pay as little as a third of that amount.

One of the reasons for these prices being as low as they are is that whether you know it or not, you are already paying for these items. Like everything else done by the United States government, the work of the Library of Congress is paid for by tax dollars, so the prices cited above cover only printing and distribution costs—not the thousands of hours that went into preparing the contents.

In any case, correspondence about any of the above items (or requesting a current catalog and pricelist of LC publications—these prices are subject to change) should be addressed to

> Cataloging Distribution Service
> Library of Congress
> Washington, DC 20541

If you are paying for a publication, the check should be made out to "Chief, Cataloging Distribution Service." (These items are also mentioned in the bibliography in the reference section at the end of the book.) But perhaps you're not quite convinced yet of how much $75 (or a free set of superseded fiche) will do for the organization of your picture library, so let's continue with how LCSH works.

LCSH is more than just a thesaurus of words; it also includes headings which can only be adequately defined by a group of words. These may consist of a noun plus one or more modifiers, given either in direct or inverted order, depending on which is the more important. Some examples:

Railroad tunnels.

Railroads, Industrial.

The headings may also consist of two nouns linked by a preposition. Again some examples:

Railroads in art.

Television in education.

And the headings may consist of two nouns linked by a conjunction where two concepts are normally considered together and there is no single term that covers both. More examples:

Weights and measures.

Television and children.

As some of these phrase headings have already indicated, LCSH is a hierarchical system. It attempts to keep related concepts together in the same filing sequence. The hierarchical structure of LCSH goes far beyond this. For most main subject headings, there are subdivisions, many of which can be further subdivided.

In most cases, these subdivisions are specifically authorized in LCSH, for example:

Minicomputers—Circuits.

But, again, no list or book, no matter how large, can provide all the specific aspects of all subjects. Here LCSH comes to the rescue with two special provisions called free-floating subdivisions and pattern subdivisions.

FREE-FLOATS AND PATTERNS

Free-floating subdivisions are ones that are applicable to many subjects and can be used without further authorization with any name or topical heading for which they make sense. Patterns work much the same way, except that they are only authorized for specific classes of subjects.

The list of free-floating subdivisions is also periodically updated in the CSBs. A list of general free-floats and those applicable to geographic headings is printed in a special booklet called *Library of Congress Subject Headings: a guide to subdivision practice,* available from the same address given above for $10 (probably the best single investment for your first

venture into LCSH). This information, which you will end up using as much as anything in the main list is not in either the book or fiche.

What are free-floats? Here are some examples from the long general list—examples which may be applicable to cataloging of photographs:

- —Accidents.
- —Art collections.
- —Automation.
- —Buildings.
- —Data processing.
- —Deterioration.
- —Employees.
- —Experiments.
- —Industrial applications.
- —Insignia.
- —Maps.
- —Models.
- —Portraits.
- —Safety appliances.
- —Study and teaching.

Knowing that "Automobiles" is a good heading from the main list, we can now construct the following headings:

Automobiles—Accidents.
Automobiles—Models.
Automobiles—Safety appliances.

Or that "Zulus" is a good topical heading, we can use:

Zulus—Buildings.

Or that if we have a picture of a group of novice librarians in a classroom learning about the wonders of LCSH, we can construct the heading:

Cataloging—Study and teaching.

Note that at this point we are not trying to eliminate other points of access—only to sub-arrange a file. For instance, for a photo of a spectacular car crash, we might want to assign both the heading

Automobiles—Accidents.

and the heading

Accidents.

which is a good heading by itself. The heading "Automobiles—Accidents" brings out a special aspect of the subject "Automobiles" and keeps you from having to look through the entire file on automobiles.

Remember that as far as subject headings are concerned, the world is divided into topical headings (categories, basically)—which are the things which are in LCSH—and name headings, which are not. It's useful to know that there are hybrid subject headings—name subject headings with topical subdivisions. These are the ones controlled by patterns.

Since it is impossible to list all name subject headings, LCSH lists one in each class, and provides subdivisions for that. For example, it is not only impossible but impractical to list the names of all universities and colleges, yet it is eminently desirable to have a group of common subdivisions. So, in LCSH, you will find a listing for Harvard University—and a listing of subdivisions. These same subdivisions can be used under any university or college. Here are some examples from the Harvard University pattern:

—Alumni.
—Athletics.
—Baseball.
—Basketball.
—Faculty.
—Football.
—Libraries.
—Students.

So, for a photo of students changing classes on the Duke University campus, we could use the heading:

Duke University—Students.

Sometimes the subdivisions aren't really "subdivisions" in the strictest sense; rather they are simply modifiers. Take for instance the free-float "Homes." It's an example of something related to a main heading which is significant (as far as cataloging goes) because of that relationship. A photo of John Doe's home may be of interest primarily because it is his home—not because it's an architecturally interesting place. So, we come up with the subject heading:

Doe, John—Homes.

In this way, LCSH keeps everything relating to the main subject together. Assigning both a main heading and a subdivision rather than just the main heading provides much better access to the specific image or images sought. If there is only a single entry or a small number of entries in that part of the catalog, the cards still file in basically the same place with the subdivisions as they would without them. But when the file grows, you'll be glad for the subdivisions, because they'll keep you from having to look through everything under the main heading. Yet, if we want to see everything related to the main subject, it's all in one place.

Here are some other patterns listed in *A Guide to Subdivision Practice*) Shakespeare, William (literary figures and authors in general); Washington, George (political figures, people in government); and the United States (national governments, governments in general). Additional information on patterns is also contained in LC's Subject Cataloging Manual.

Again, this is all more complicated to talk about than to put into practice. The vast majority of the subject headings you will use for photographic

collections will consist of a single element, though you will want to use more than one subject heading for each image or group of images—the old multiple access game, remember?

GEOGRAPHICAL SUBDIVISIONS

Let's consider a group of photos of John Doe and Susan Smith at Yellowstone National Park. Some possible access points in a catalog:

> 1. Doe, John. 2. Smith, Susan. 3. Yellowstone National Park.

All three are name headings and will get us to photos of the named person or place. That's fine, if you know those names. For a commercial stock photo collection, the place heading may be useful. To really get maximum use out of the images, however, we also need some access points for the activities and type of place—topical headings:

> 4. United States—National parks. 5. Hiking—Wyoming. 6. Camping—Wyoming.

The last two are examples of topical subject headings with geographical subdivisions. These, too, follow a hierarchy. With a couple of specific exceptions, geographic subdivision in LCSH is done following "indirect" practice. Indirect takes the form:

> [Topical heading]—[Country or state]—[Locality].

Example:

> Airports—North Carolina—Durham.

Direct would look like this:

> [Topical heading]—[Locality].

Example:

> Airports—Washington (D.C.)
> Airports—Jerusalem.

The only localities (cities) that are done direct are ones where there are problems with using a larger jurisdiction as the first modifier. For instance, Washington (the capital city) is not part of any state, and coincides with the District of Columbia. Similarly with Jerusalem having been a divided city, and even pre-dating the existing countries in the Middle East, LC decided to use Jerusalem directly. Similar reasoning has been used for the other cities which are used directly when modifying topical headings. Here are the exceptions to indirect subdivision practice (and, yes, folks, these are all the exceptions):

> —Berlin (Germany)
> —Jerusalem.
> —New York (N.Y.)
> [not "—New York (State)—New York."]
> —Washington (D.C.)

(Note that three of the indirectly accessed cities still require qualifiers.)

The LCSH topical list (book or fiche form) contains an indication as to whether a subject is to be geographically divided by showing "(Indirect)" after the heading. This indication is given with main headings and subdivisions, including some free-floats, and includes application of the four above-named direct exceptions. Headings that do not show the "(Indirect)" indication are not intended to be divided geographically—though libraries sometimes do so nevertheless. In part, LC's decisions not to have certain subjects subdivided geographically were made because it may not make sense to do so; in part, they were an attempt to keep cataloging from getting overly complicated. In any case, we'll look at the wisdom of going against LC practice later on.

LC has decided to switch to indirect—rather than direct—geographic subdivision because the hierarchy of indirect subdivision provides some direct benefits in subject access. To understand these, we first need to look at the rules for indirect geographic subdivision. The first basic rule is that there are never more than two steps in the geographic hierarchy. For the U.S., the first element is always the state. For the following countries, the first element is also below the national level—province, constituent countries or republics, respectively:

 Canada
 Great Britain
 Soviet Union

For places in all other countries, the country is the first order subdivision.

The limitation to two elements, though an artificial one, is not as arbitrary as it may appear. Remember, the geographic division may come at the end of a topical heading which itself may already contain several elements. Beyond a certain length, headings become unwieldy and difficult to file in a catalog.

By now, you may be beginning to see that the Library of Congress Subject heading system is slightly easier to use than to talk about.

Before leaving this introduction to LCSH, it's worth noting that the main subject heading list (in book and fiche form) not only gives you the "correct" form to use among terms and phrases which mean the same thing, but, like all good thesauri, also provides links to the "correct" forms of headings for related subjects, including broader and narrower concepts.

That's important because it lets us assign very specific headings to a particular item without having to also use all possible broader terms including the specific concept. If you're looking for anything under a broader term, LCSH will show you what narrower terms to look under for additional material. It's something we'll get back to when we consider authority structure in catalogs in a later chapter.

THE ANGLO-AMERICAN

CATALOGING RULES

Rules for Absolutely Everything
Are a Mixed Blessing

Do you enter (make a heading that files) a picture of a fraternity chapter under the name of the college? The name of the national fraternity? The chapter name? Or the name of the city that it's located in?

Cataloging rules try to help by making things predictable.

If anything, the *Anglo-American Cataloging Rules* (*2nd ed.*) or AACR2 are rather overwhelming at first glance—and maybe even more so at second glance. There, in great detail, are rules specifying where every comma, semicolon and dash go within a cataloging record. There, in 637 pages, are rules for cataloging absolutely everything.

And, that word—everything—is precisely why the rules are so long and complex. To avoid being intimidated by this weighty tome, look at it in perspective. The rules were designed for library catalogs that may represent not only books, but also maps, pamphlets, posters, original art works, slides, videotapes, phonograph records, photographs, movie films, architectural models, as well as any other medium in which information may be stored. With books, minor differences in typography may be the only clues to differences in editions—something that can be of vital importance to scholars. For that reason, there are pages upon pages of rules on how to transcribe information from title pages and elsewhere in books—all of which doesn't apply to photographs.

This, however, doesn't mean in the least that there isn't a lot that can be of use. And, once you learn which sections to ignore, the book isn't all that intimidating anymore.

For now, all we're going to worry about is the section that tells us how to make name headings, or chapters 22 through 24 of AACR2. These rules address the form of name headings for people, geographic jurisdictions, organizations and meetings, and consider these headings from the descriptive end of cataloging. That is, they talk about people, organizations, etc., as they would be treated as headings if they authored a work. Since it is only logical that the same form of heading be used for people, organizations, etc. when they are treated as authors and when they are treated as subjects of a work, the LCSH defers to AACR2 for the formulation of name headings.

AACR2 devotes three entire chapters to how to formulate name headings for people, geographic jurisdictions, and organizations. Let's focus our attention for a moment on the category of organizations, for which we will hereafter use the library term of corporate body or corporate heading.

CORPORATE HEADINGS

There are a vast range of things which fall under the designation of corporate bodies. All types of government organizations from the city council to the U.S. Senate are corporate bodies. Many organizations, from the just mentioned governmental agencies to your local lodge, fraternity or sorority are parts of larger organizations.

You may be surprised by the number of things that fall into the category of corporate bodies. For instance, a ship is a corporate body for cataloging purposes. After all, a ship isn't just something made of wood or steel; it's also an organization of people capable of "authorship." A ship's log or a ship's newspaper would represent items which are the product of the organization rather than of an individual. So among the rules for corporate bodies, there is one for how to enter ships.

PERSONAL NAMES

Even the business of personal name headings is more complicated than it appears. Let's take the case of a certain president of the United States. Sure, the main rule is last name first, first name, middle name. And that's going to take care of a lot of cases. But is

 Carter, Jimmy.

or

 Carter, James Earl.

the correct form? And does it really make any difference?

In the beginning, in a small catalog, it probably wouldn't make that much difference if you used one or the other; even if you used both

headings interchangeably, they would file together in the same section of the catalog.

But with cataloging, you don't get into trouble at the beginning, but far down the road, problems become time-consuming and expensive to fix. Let's suppose that we really had used both versions of the name. Then along came other people named Carter, for whom we have material in our collection. Before long, you have a filing sequence that looks like this:

> Carter, James Earl.
> Carter, Jane.
> Carter, Janet.
> Carter, Jesse.
> Carter, Jethro.
> Carter, Jimmy.

The examples could go on and on. The point is that if you have enough Carters and enough cards for each, the cards for "Carter, James Earl" and "Carter, Jimmy" could actually be in different drawers of the catalog. You could, of course, arbitrarily pick one of the two versions. But even if you remembered from one time to the next, how would someone else?

Rule 22.1A: Choose, as the basis of the heading for a person, the name by which he or she is commonly known.

So, it's "Carter, Jimmy."

Note that the rule said "basis of the heading" because the rules also provide for additions to names to distinguish one person named Jimmy Carter from another with the same name. The most common means of dealing with this is the addition of dates. The heading for the former president would be:

> Carter, Jimmy, 1924–

But first, there are more pages about "entry element." That's an elaboration of the last-name-first routine. Even that needs some elaboration.

What about the case of the prefixes that are part of a name, as in Wernher Von Braun or Abigail Van Buren? Do you make the entry

> Braun, Wernher von

or

> Von Braun, Wernher

in this case? The rules specify that the latter would be correct.

The choice between entry under the very last element of a name or a prefix is determined in part by that person's country of residence. For Americans and residents of other English speaking countries, the general rule is "Enter under prefix."

There are even rules for countries and languages that don't have "last names" as such and for names in languages that don't use the roman alphabet. Usually, these rules aren't arbitrary. They simply attempt to codify the use of names in various parts of the world.

There are some rules relating to the creation of headings that you will use constantly, often without even thinking about them. Some you'll use occasionally, and some that never apply to anything you catalog. The most commonly applicable ones will quickly become second nature. For the rest, all you need to do is recognize that a name may not fit under the more general rules—and then look up the applicable instructions.

Great effort went into making the arrangement of AACR2 as logical as possible, going from the general rules to the more specific and then enumerating special exceptions. Major sections have their own tables of contents and there is an over-all index and glossary of terms at the back.

As with the topical headings discussed in the previous chapter, there are also provisions for hierarchical structuring in name headings. This comes into play most often with governmental bodies, or where the organization being indexed is a subpart of a larger corporate body and the name of the subpart alone is not sufficient for identification. Some examples:

> North Carolina. General Assembly.
>
> United States. Army. Corps, XVIII.
>
> Psi Upsilon. Gamma Chapter (Amherst College)

The last case, of course, answers the question of how fraternity and sorority chapters are entered, which we asked at the beginning of this chapter.

HYBRIDS

In the previous chapter, we saw that parts of the topical hierarchy are separated by dashes (or a double hyphen, in the case of typed cataloging records); within a corporate name heading, the hierarchical elements are divided by a period followed by two spaces. The distinction is important. Remember, we can have hybrids—name headings with topical subdivisions (either out of the free-float or pattern lists). Here are some examples of these hybrids:

> Robl, Ernest H.—Homes.
>
> Vienna (Austria)—Aerial photographs.
>
> Duke University—Buildings.

In each case, the first part of the heading is a name heading not found on the LCSH list, while the second part is a category or group of things which defines a special aspect of the name heading. Some other examples:

> Washington (D.C.)—Maps.
>
> Rockefeller, John D., 1906– —Art collections.

One thing that may be apparent from the above two cases is that they

would be subject headings for something related to the name heading—not for the named item itself. The logical access to the image we want is through the name heading. We are interested in the map of Washington, not just because it is a map but because it it a map of that specific city. We can also use the general heading "Maps" to keep together in one section of the catalog an overview of all the images we have of maps.)

It's important to note that if we were cataloging photographs or slides of any of the above subjects for a library housing a variety of media, such as books, audio recordings, etc., the subject headings would be followed (in standard cataloging practice) by one of the two free-floating subdivisions:

> —Slides.

or

> —Photographs.

Material designations like these can be added for any non-book ("non-print") material. Only books and other similar printed materials don't get special designations—a case of librarianship's pro-book prejudice showing. While these additions to subject headings make sense in mixed collections, they would be rather pointless or even silly in a collection composed entirely of images. If I had followed that practice, it would have resulted in a lot of unnecessary clutter in my catalog.

Still another possibility in the hybrid name heading-topical subdivision category includes name headings with a hierarchical structure, modified by one or more topical subdivisions. Example:

> Great Britain. Embassy (U.S.)—Officials and employees—Portraits.

This subject heading would index a group of portraits (or a group portrait) of employees of the British embassy in the United States. The embassy is entered hierarchically because it falls under some special rules for government organizations; "Officials and employees" is a topical subdivision that delineates a special aspect of that corporate heading. "Portraits" provides further refinement of the already defined subject. Each step in the hierarchy either subdivides or modifies everything that has come before. Although the subject heading consists of a multi-step hierarchy, it's all one subject heading.

Local areas do not have to be cities, and those that do not clearly fit into one of the first element categories or that overlap several of them are entered directly.

A MODEL CATALOG RECORD

All of which still hasn't gotten us very far into the catalog record. Let's look at the catalog record we would get by following the Anglo-American Cataloging Rules. In this case we're looking at the basic skeleton of a

record (as it would appear on a catalog card), which is applicable to all formats from books to photographs.

```
[Ad-        [Main entry (author)]
dress]           [Main title] : [subtitle] /
            [statement of responsibility]. --
            [edition statement]. -- [Place of
            publication] : [Publisher], [date
            of publication].
                 [Physical format].
                 [Notes].

                 1. [Subject heading]. 2.
            [Subject heading]. 3. [Subject
            heading]. I. [Added entry]. II.
            [Added entry].
                         O
```

The Anglo-American Cataloging Rules don't care about what type of address we use or how we format it.

The main entry would be the equivalent of the author—the person or organization (or conference) chiefly responsible for the work being cataloged, if this can be determined—with the entry being in proper AACR2 form, of course.

In cases where the chief responsibility cannot be determined, or where the work is a collective effort of several people or organizations, the cataloging rules specify main entry under title. To make it clear that this is the case and that a personal, corporate or conference main entry has not just been accidentally deleted, the main descriptive paragraph is done in hanging indention format. Like this:

```
[Ad-        [Main title] : [subtitle] /
dress]           [statement of
            responsibility]. -- [edition
            statement]. -- [Place of
            publication] : [Publisher],
            [date of publication].
                 [Physical format].
                 [Notes].
            . . . .

                         O
```

The rest of the record would be the same.

Now, about the title: For items lacking a title, AACR2 says, "devise a brief descriptive title." The rules also say that where the cataloger is supplying information not found on the item itself, or in specific locations on the item, the information is enclosed in square brackets. Further, the rules say that for other than printed page material, a "media designator" is added after the title. These come from a specified list that includes (for North American usage):

 map
 art original
 chart
 filmstrip
 picture
 slide

For a library consisting entirely of photographic images, this would mean that every title would have "[picture]" or "[slide]" after it.

Then comes the statement of responsibility. Where it's available on the item being cataloged, it's transcribed from that item in the form given. Photographs aren't published in editions—normally—so, we don't have to worry about edition statements. In fact, since photographs generally aren't published in the normal sense of the word, we don't even have to worry about a place of publication or publisher. Chapter 8 of ACCR2, which contains special rules applicable only to graphic materials, says that all we supply in this area is the date—in square brackets, if it isn't on the item being cataloged.

The date can take several forms, depending on how closely we can determine it:

 ca. 1960—date approximate
 1971 or 1972—date narrowed to two years
 between 1961 and 1970—range of possible dates
 1975—year certain

Of course, with many pictures, we can go the rules one better and specify the exact day. For many pictures, the date that the photo was made can be of key importance.

Now, for the physical description—for book material, this would consist of three basic areas: paging (or volumes), an indication about the presence of illustrations, and dimensions. The prescribed punctuation is space-colon-space between the first two elements and space-semicolon-space between the second and third.

Chapter 8 again has some special provisions for graphic materials. Here, the first element becomes the number of items. Since what we are cataloging is an illustration to begin with, the second element is used to specify color or black and white. The third element gives the dimensions, though when slides are specified in the first element, the dimensions do not have

to be given unless they are other than the 5 x 5 cm format (2 x 2 inches).
Some examples:

> 24 slides : col.
>
> 12 slides : b&w ; 7 x 7 cm

Since the size of the mount will determine the type of container in which
the items can be stored, that, rather than the image size, is specified in
the cataloging rules.

Up to this point, punctuation used to divide areas of the catalog record,
rather than being used in its normal grammatical sense, is both preceded
and followed by a space.

This standardized punctuation has several uses. First, it makes a quick
overview of the record possible. And, second, it allows a catalog user to
identify elements of a record even if the entire record is in a foreign
language.

The notes use normal grammatical punctuation; the tracings are format-
ted according to the rules for headings. The arabic numbered ones are
subject headings; the roman numbered ones are added entries for people,
organizations, or conferences (other than the main entry) who have con-
tributed to the work being cataloged.

GROUPING AND

ADDRESSING

PHOTOGRAPHS

A Few Words for Description and
against Classification

When we looked at a cataloging record for a mythical book earlier, we found that the record consisted of a number of parts: a descriptive paragraph, the physical format, additional information in the form of notes, and—most important—an address and a number of access points. No matter what type of subject heading system you use, remember, the subject headings are nothing more than access points—doors that lead you to where you want to get.

Now, let's look at putting the entire record together.

The first question to ask ourselves—since it is going to affect other factors—is whether the cataloging record is going to represent a single item or a group of items.

Since cataloging is a time-consuming and therefore expensive process and we want to use the simplest solution that will accomplish its purpose, in most cases, there is little choice but to opt for cataloging groups of items. Only a few collections, perhaps ones comprised entirely of highly valuable historic images in the form of their original glass negatives, would be able to afford an iron-clad rule to catalog each item individually.

Of course, a decision to normally catalog groups of items rather than individual images does not preclude the possibility of having a catalog record represent only a single item, if that item does not fit into any group—if that item is somehow unique.

CATALOGING GROUPS OF IMAGES

Once the decision has been made to opt for the group rather than the individual item, the next question is how to delineate the groups. The most obvious grouping—using the film that the images are on or the box that the slides come back from the processor in—is probably the least useful, though it may sometimes coincide with other logical groupings.

How large a group of items are you willing to have represented by a single cataloging record? Looking in a catalog under a specific access point we will find one or more catalog records. Not everything represented by each of those records—the group of images represented by that record—will necessarily match with that access point, but at least something in each group should.

For example: we have a group of 57 transparencies of John Doe and Susan Smith hiking and camping at Yellowstone National Park. Earlier, we had decided that the following access points might be useful:

> 1. Doe, John. 2. Smith, Susan. 3. Yellowstone National Park. 4. United States—National Parks. 5. Hiking—Wyoming. 6. Camping—Wyoming.

While every slide may match with the third heading, not every slide will necessarily have John Doe in it.

Understanding this concept is important because you will be searching your catalog in one of several possible ways: You may be looking to see if you have anything of a specific subject; you may be looking for everything you have on a specific subject; or, you may be looking for a specific item represented by that heading.

For instance, we may be looking for any picture of John Doe because the publication that requested the picture simply wants one that shows what John Doe looks like. With a few general limitations any picture of John will do.

Or, someone may be working on an illustrated biography of John Doe. We are looking for every available picture of John in this case.

Or, finally, we want a very specific picture that we remember of John Doe standing in front of Old Faithful. A book publisher saw this photo in a magazine and now wants to use it on a book cover. He wants that particular photo—and nothing else will do.

The reasons for each type of search really aren't as important as the categories themselves. As long as we opt for group cataloging, we will have to look through at least one group of images.

The maximum number of items in a group may well be the maximum number you are willing to look at or can look at within a reasonable period of time to locate a specific item.

To locate the slide of John Doe in front of Old Faithful, we first narrow the entire collection down to those groups of images for which John Doe is an access point (subject heading). By reading the descriptions (we'll get to descriptions in a moment) of the various records, we now narrow the collection to a specific group of images (described on one cataloging record). We will then have to look through that group to find the specific image.

In my personal file, the number of slides represented by a catalog record runs from one to about 200; the vast majority of records, however, represents somewhere between 10 and 50 slides. I will go over 100 slides per catalog record only in cases where there is no simple way to subdivide the group.

I file my slides in drawers designed for group filing. Once the search has been narrowed to a specific group, it's a simple matter of running that group either through my stack-loading slide viewer or through the stack loader of my projector. Either will take a maximum of about 40 slides. A group of 100 slides would have to be run in three batches. A quick scan of that number of slides would take somewhere between one and two minutes.

We'll look in greater detail at storage methods later, but for now it's worth noting that if you stored slides in transparent plastic pages—20 slides to the page—it would take about the same amount of time to scan five pages on a light box. On the other hand, however, if we filed these slides in a file with individual slide slots, requiring each to be removed and replaced one at a time, it will take considerably longer to view 100 slides.

So, the type of storage and viewing systems used may have some effect on the maximum number of slides per group. Other than that, how do we delineate the groups?

There, too, there are no absolute rules. By assignment may be a viable division for the pro; by trip or subsegment of a trip may be a useful division for the travel photographer, whether professional or amateur.

Subject overlap is a major consideration. Let's consider a total of 50 transparencies which we want represented in the catalog; the question is whether to use one or more records.

If we can divide the total into two groups—slides 1–27, which will be represented by subject headings A, B, and C; and slides 28–50, to be represented by subject headings D and E, the logical choice is to represent these slides with two different records. Doing that is going to reduce the number of slides you will need to look at while hunting for items within any of the subjects.

However, we may need to divide the slides into group 1–27, which

will require subject access points A, B, C and D; and group 28–50, which will require subject access points A, B, C, and E. If we are using a card catalog, we are going to have more entries (cards) in the catalog than if we used only one record. Now there are two cards for subject heading A (one from the record for the first group, one from the second); two for B; two for C; and one each for D and E. In other words, we have ten cards (including one shelflist card for each record) instead of the six we would have from one record using only one card for A, B, C, D and E (including one shelflist card).

If we are looking for a specific image indexed under subject heading A, we may be able to find it by looking through fewer slides, but we will have to look through more records to locate the right group. If we are looking for all possible items represented by subject heading A (the all possible photos of John Doe situation), we will have to look at two records, rather than one, but the same total number of slides. On this front, we have actually lost some ground rather than gaining anything by dividing the slides into two groups.

We would, of course, have reduced the number of slides we need to look at when searching either subject D or E, but is the overall effort—creating two records instead of one, reproducing two records instead of one, and filing additional cards—worth it, considering we've actually lost ground on some types of searches? I opt for the single catalog record.

Since the goal of any cataloging operation is to be able to find items as efficiently as possible, the cataloging of slides normally presupposes some kind of editing of the slides themselves—at the very least to discard technically flawed images which have no possible future use. These flawed images will waste your time whenever you look through a particular group, besides taking up valuable storage space.

In addition, we often don't shoot photographs in the most logical sequence for viewing. There's no reason not to rearrange them into such an order if strict chronological order is not needed. To avoid a lot of lens-changing I normally work with two and sometimes even three 35mm camera bodies. For cataloging, it makes sense to group images of the same subject from each of the films together at cataloging rather than arranging the films one after another as received from the processor.

This logic may not apply for negatives, however. Particularly with small-format negatives, it is not desirable to cut apart individual frames simply because they are difficult to handle in that condition. However, the negatives are not the final product, anyway; prints are. These can be re-sorted into any desired sequence for presentation or viewing.

So much for why individual films may not be the best available units for grouping images for cataloging.

ASSIGNING CALL NUMBERS BY SUBJECT CLASSIFICATION

Although I've devoted a great deal of space to subject access, I haven't yet mentioned subject classification of cataloged items. By classification, I mean the way we assign the "address" to individual items.

There are basically two methods of designing these addresses, identification numbers or call numbers: one is to use some type of subject classification scheme; the other is to use some type of accession numbering. Both have advantages and disadvantages.

When we looked at the cataloging record for a hypothetical book earlier, we noted it had an address within the library collection that looked like this:

> 025.1771
> R666
> O68
> 1986

We noted in passing that this library was using the Dewey Decimal classification system, and that the book had been classified in a number on library management. The first line of this address is the Dewey number; the second though fourth lines distinguish this book from other books on the same subject by providing for the author, the title and the date of publication.

Specifically, the Dewey number represents: 025 for library science; .1771 for pictures. That Dewey number alone is not enough to distinguish the item, however, in most larger libraries. Quite conceivably, the library could have two or more books in that number. Many classification numbers, such as those for specific geographic locations, will almost inevitably contain several items. This is where the "book number" comes in. It consists of two lines derived by looking up the name of our hypothetical author and the title in something called the Cutter-Sanborn Tables. The line with the R666 distinguishes books by a particular author within the classification number; the O line ("Cuttered" to the title) covers the possibility that the author may have written more than one book about this subject. The date provides for distinctions among different editions.

Of course, it's possible that a particular author may have written two different books on basically the same subject whose titles begin with the same word. Or, it's possible that there may be several authors with the same last name writing in the same subject area. A library may even own multiple copies of some works. In each case, some further distinction is necessary to give each item a truly unique address or item number.

This points out one of the basic problems of classification systems. The subject classification alone is never enough to distinguish an item. The same basic breakdown of the number discussed above also applies to the Library of Congress classification system—the other major system used

in general-purpose American libraries. Though its subject classification designation consists of a combination of letters and numbers, rather than just numbers, it too adds an author and title designation to distinguish individual items—and sometimes has to further augment these to distinguish editions, etc.

The other basic problem with classification systems is that they are one-dimensional. We've already seen that to adequately represent the subject of a book—or a photographic image or group of images—we usually need more than one subject heading. Obviously a single item can only be assigned one address, regardless of what system is used.

Using a classification system does give a collection some browsability. Within certain limits, you can expect to find material on the same subject in the same general area. Library users will still have to use the catalog to find specific items, but in a very large library just finding all the books on mathematics on the same floor can be a considerable advantage. The latter situation is less of a factor with a picture library, where several hundred thousand slides can be stored in a moderate sized room.

In addition to everything else, both the Dewey and LC classification systems are highly complex and the reference material you need to apply them is expensive. The latest (19th) edition of Dewey runs three thick volumes and costs $90. And it's not just a simple matter of looking up a number. Many numbers have to be "built" using a combination of tables. A complete set of the LC classification schedules runs nearly two dozen volumes and more than fills up a three-foot bookshelf.

With either of these systems, there is a question of how specific you want to make the number. Theoretically, you can design a number for almost anything—left-handed Lithuanian immigrants residing in Chicago; computer use by farmers in Lesotho, Africa. The problem is that in these cases, by the time you take care of all the aspects of the subject, you can end up with classification numbers alone that run to more than 20 digits. It's extremely difficult to shelve or retrieve by these very long numbers—not to mention trying to get these numbers onto the item itself. Think about trying to get a 25 digit number onto a 35mm transparency mount.

And arbitrarily shortening a classification number to a specific number of digits defeats part of the purpose of the classification system. If your collection specialized in one general subject area—say education—and you keep your classification to four or five digits, virtually everything is going to be in the same classification number.

THE ADVANTAGES OF ACCESSION NUMBERING

With classification you spend a lot of time agonizing over something that really doesn't make a lot of difference if you know how to use a catalog

correctly. Having used Dewey in the cataloging department of a large university library (where my duties included teaching the Dewey system to new staff members) and being reasonably well versed in its intricacies, I decided not to classify my collection.

Instead, I chose to use a modified accession numbering system—something I highly recommend for most other picture libraries.

Accession numbering simply means numbering items sequentially in the order they go into the collection. After all, one kind of address is as good as another.

I use a six digit number for my slide file, with the first two numbers being the year. The first slide for 1983 was 830001. This lets me add up to 9,999 slides per year—far more than I can presently conceive adding in 12 months, especially since I tightly edit my own takes and keep only a small percentage of what I shoot. Should I ever find that I'm expanding the collection at a faster rate, I can always add on another digit.

DESIGNING DESCRIPTIVE
RULES FOR
YOUR COLLECTION
How to Bend Library Guidelines—and Why

Now that we've learned how to do a cataloging record right, it's time to think about how to do it wrong. Or, maybe this is a better way to look at it: it's time to look at what parts of standard cataloging don't serve any purpose for what we need. First, let's consider how catalog records are combined into a catalog.

ARRANGING YOUR CATALOG ENTRIES

The access points we've considered so far can be divided into several categories: The addresses, the main entries, the title, the subject headings, and the added entries for other contributors.

Of all the above, only the address does not consist of words that can be filed alphabetically. Regardless of whether these call numbers consist of classification or accession numbers, they will need to be filed in a separate sequence—the shelflist.

The remaining access points can be arranged in a number of ways. They can all be interfiled in one sequence or grouped into several segments of the catalog. On the one hand, it may be convenient to have both items by John Doe (Doe, John—the photographer—as a main or added entry) and items about John Doe (Doe, John as a subject heading) filed in one sequence; on the other hand, it can be confusing to catalog users.

To alleviate some of these problems, many libraries divide their alphabetical catalogs into an author-title section and a subject section. Main entries and added entries (including titles) are filed into an author-title catalog; subject headings are segregated into a subject catalog.

While titles found on items being cataloged may be useful access points, we've already found that photographs are not going to have any titles other than the ones we supply. Since different catalogers will probably supply different descriptions of the same image or group of images, these are generally not useful as access points for pictures. Besides, this nonstandard information can be presented in a standard format in the form of subject headings.

Now you need to ask yourself, "Do main and added entries serve any purpose for my collection?" Do you need access by photographer?

For someone collecting photography as art, access by photographer is vital. For an individual photographer's collection—whether that collection is the result of photography done as a business or photography pursued for pleasure—access by photographer is obviously not needed since the entire collection is the work of the same person.

Even for a photography business where the collection is the result of work by a number of people, access by photographer may not be needed. A commercial client is going to be interested in finding a particular image to meet his needs; in general, he is not going to be interested in who created that image.

Which is not to say that the photographer is unimportant, or that we may not want his name on the catalog record, or that we do not want him to get due credit in print when his work is published. I care as much about my credit line as any photographer. But from the librarian's point of view, I'm also very aware that cataloging is very much a matter of what you can afford—and what serves your purposes.

And so, for my own photographs, my cataloging records begin simply with the description, eliminating the main entry. This is only one of a number of adaptations which lets me get other—more relevant—information on the catalog card.

There are always cases where you somehow acquire photos made by someone else and want to keep them as part of your permanent collection. If you want "author" access to these, you still can have it, by setting up a separate file for this purpose, as I did. Into this file go cards for each record representing work created entirely by someone else, as well as added entry cards for records basically representing my own work—but to which someone else contributed substantially.

In short, for other people's work, I do much more "standard" cataloging than I do for my own.

DESCRIBING THE IMAGE: WHO, WHAT, WHEN, WHERE, WHY AND HOW

Now, we come to the description—the ultimate problem of translating pictorial content into words. The cataloging rules give little guidance beyond saying that where the item being cataloged has no title that can be transcribed, the cataloger is to supply a brief "title" or description.

The first thing every beginning journalism student learns about writing a news story is to answer six basic questions: Who, what, when, where, why and how. To me, these also appear to be good guidelines as to what to mention in the description. All are not always going to be applicable to every group of items cataloged. But if you at least consider this list in creating every cataloging record, then you can be assured of having adequate information to caption or explain that group of images in the future.

The cataloging rules also provide for a media designator to be given in brackets following the title for all non-print (i.e. non-book) materials. Where one catalog serves as a combined index to a diverse collection, then the media designation serves a purpose by quickly alerting the user to the type of material represented. Where the entire catalog represents only photographic images, however, the words "photograph" or "slide" serve little purpose. Granted, we may want to distinguish between slides and other types of photographic images, but there is also provision for this information in the collation or physical description area, and we can take care of that there. So, another bit of "standard" cataloging can be spared at this point.

The description paragraph of a standard cataloging record also includes an authorship statement following the title. But again, for a collection of photographic images consisting entirely of the work of one person, the statement of responsibility would only be an unnecessary restatement of the obvious. When cataloging my own work, I leave it out. For the work of others, or where someone else has contributed to the work cataloged, I do include it.

In fact, the statement of responsibility is one area where I've gone beyond the provision of the cataloging rules because of something that applies to photographs that hardly ever applies to other types of material: namely, that photographs are not only made by someone, but very frequently are also made for someone or some organization. Knowing why a photograph was made can be very important to understanding it.

Remember that the rules prescribe a space slash space (/) between the title and the statement of responsibility. The statement describing for whom the photos were made could be put in this area with the appropriate words of explanation. I use a double slash (//) to denote for whom (frequently a publication) or for what purpose particular photos were made.

For my own work, I use this statement alone when it is applicable to a particular record; for work by someone else, it comes after the statement of who made the photos.

The last part of the normal descriptive paragraph contains the place of publication, publisher and date in that order. Because photographs are not "published" in the usual sense, the cataloging rules call for only the date in this area—the date the photograph was made. Since, however, the "where" is one of the bits of information that we want to include in the cataloging record, I find it convenient to set off this information in the place-of-publication area—a specific place in the record where it is set off by specific punctuation and easy to find, even if it is not used as an access point.

As for the date, normal cataloging practice is to record only the year of publication or year of creation. Often it is important to know the date in greater detail. For instance, the specific date of news photographs can be of great importance. So, I always record the specific day or range of days, when a group of slides was made over several days. The specific day is stamped on each slide—something we'll get to later.

THE COLLATION

That brings us to the collation—the physical description of the material. Following the standards set down in AACR2, the line would look something like this for a group of 27 slides in the 35mm format:

27 slides : col.

Under the cataloging rules, 2 x 2 inch mounts are assumed unless another dimension is specified. For mounted 2¼ x 2¼ transparencies, for instance, it would be:

27 slides : col. ; 7 x 7 cm

Since the range of consecutive numbers in my call number shows the number of slides in the group cataloged, I initially decided I didn't need that number in the collation; besides, in most cases where I'm searching the catalog, I'm interested either in a specific image or whether I have an image of a particular subject. So, I began by simply noting the format—and I went the cataloging rules one better by specifying horizontal or vertical or both. (Lately, though, I've gone back to specifying the total, since it doesn't take that much extra effort to provide it, and it makes my cataloging a little closer to the standard.)

Usually, a publisher looks not only for an image of a particular subject, but also for an image to fit a particular space. And an editor is not going to be too wildly enthusiastic about horizontal images for his cover.

With my system, the catalog record doesn't guarantee that any one image in a group is going to be in the desired format, but it does save me from looking for a vertical image in a group consisting entirely of

horizontal ones. It's just as important for your catalog to tell you what you don't have as what you do have. My collations look something like this:

> 35 c : h & v (my early records)

or

> 12 : 35 c ; h only (current cataloging)

The 35 is for 35mm film size, the c for color slide. Why use those when I only catalog slides?

First of all, I do occasionally make black-and-white slides—copies from black and white originals for use in slide presentations. Sometimes I shoot tables or technical drawings on high contrast negative film that I mount as slides. For those, I use "35 bs" or "35 rs" (for reverse text slides in the latter case).

One of the things you always want to do when setting up a catalog is leave yourself some options for the future. At some point, I may want to catalog negatives, too. All I need to do is use a different designation. Also, I do sometimes shoot 6 x 6 cm transparencies.

In the end, however, it comes down to a matter of convenience and preference. Any time one type of material predominates a collection it is possible to assign a "default value." This data processing term simply means that a given condition is assumed to exist unless it is specified otherwise. This is already incorporated into AACR2 in some cases, such as the assumption that slides are 2 x 2 inch format unless specified otherwise. I use the same concept in my catalog to indicate who the photographer is, the assumption being that all the photos represented in a particular catalog record were made by me unless specified otherwise.

Default values need to be explained to each new user of the catalog. You can simply give this information on a handout sheet to each catalog user, or post it somewhere near the catalog—or both.

The judicious use of these default values can save you considerable space in your catalog, whether it's in number of cards filed in a card catalog or in data storage capacity on a computer disk. You will save time in cataloging, too.

THE NOTES

Now, for the notes. What do you put in those? Anything and everything that's going to be of use in retrieving pictures. AACR2 leaves that option open. The rules do indicate some cases where specific notes should be made in the cataloging of graphic materials, though standards are not as extensive as for print (book) materials.

Basically, the notes let you add to the brief descriptive paragraph. With

books, a frequently used note is the contents note. It would be used, for instance, to list plays in an anthology, or the titles of individual volumes in a set of books cataloged together as a single unit. The contents note lets you highlight specific images within a group; other notes depend on the nature of your collection. By standardizing the way you present information in these notes and judiciously using a few abbreviations, you'll be surprised how much information you can get into a single catalog record—or fit on a single card.

Typical situations in which you would probably want to have notes on your catalog record are: limitations on using the images cataloged; imperfections in the items cataloged; directly related items in the collection (or elsewhere) from which the image is derived; and citations for additional sources of information relating to the items cataloged. Some examples:

Limited Use. If you photographed copyrighted material, you would certainly want to note the copyright status. The copyright laws have certain "fair use" provisions under which you could photograph a copyrighted map and use it in a slide presentation to your friends about a trip you made. But you wouldn't—unless you really want to get sued for infringement—submit that slide to a publication or include it in a commercial slide show for which you are paid without proper clearance from the copyright owner. There may be numerous other situations where, because of legal or ethical reasons, you want to remind yourself of limitations on the use of the images. You may have sold all rights to a particular group of images but retained culls for use in your portfolio.

Conversely, where you have specific legal protection in the form of a model or property release, that should also certainly be noted. For my collection, the default value is that there is no model or property release. If you file your model releases in sequential order, the note for the presence of one could take this form:

Model release 83–12345.

Imperfections. Again, the assumption is that the images cataloged are in technically good condition, properly focused, exposed, etc., unless otherwise specified. Usually, it is logical to edit out imperfect images prior to cataloging. There are, however, cases where you may elect to retain images despite their imperfections. A photograph may have a high sentimental value despite being poorly exposed or slightly out of focus. A note would warn of commercial liabilities:

Slightly out of focus.

Of course, a highly exclusive grab shot, even with imperfections, may still have commercial value. Yet, you would still want to note these imperfections on the catalog record.

Related items. Although I presently do not catalog black and white negatives, I do make a note on the catalog record to remind myself that I also shot black and white of the same subject:

>Also b&w.

Or, you may make a copy transparency which superimposes text over an image; the new image, because of its modification, becomes a separately cataloged item, with its own number (address). For instance, the main description may be something like this: Title slide "North Carolina" : over sunset The note might read:

>White text over 760123.

Citations. If, at the time of cataloging a group of slides, they have already been published, I cite the publication in a note, because the published text can certainly supply more information than a brief catalog record. Even without publication, if I've written an article or extensive caption material for a publication or potential client, I cite that:

>Captions in FC83 (ILF30616); cov. let. 6/16/83.

(The FC83 identifies both a file folder and a computer disk for my word processing system; the ILF30616 is the file name on the computer disk.

Tests. Photographers face another special situation—the testing of a new piece of equipment, a new type of film, or whatever. I usually retain all test images, even otherwise unusable ones. At some point in the future, I may want to check back on what one stop over- or underexposure with a particular film looks like. The description would say: Test photos : [name of equipment, film, etc.] In addition to the normal subject headings for the subject content of the images, I also make a subject heading for the item being tested in this form:

>[Equipment, film, etc.]—Test photographs.

These tests are the only time I normally record technical data—specific exposure, frame by frame, and conditions under which the photos were made, including lighting. All these details take up quite a bit of space, and aren't really needed at every access point in the catalog. So I put this information on one or more cards which are filed behind the applicable catalog record in the shelflist. My standard note is:

>Data card in shelflist.

ALTERNATIVE FORMS OF DESCRIPTION

Before we get on to the access points, there's one more point on the "description" that bears emphasis. And that is that a number of visual libraries have abandoned the "normal" descriptive paragraph in favor of some special arrangement of information. This departure from the rules does not preclude any specific system of assigning subject access points.

One such arrangement often found might be called "fill in the blank." This is most useful where every image (or a large proportion of the images) has the same elements that need to be brought out. The following example might be used in a library that contains only architectural images:

Name of structure:

Architect/designer:

Style/school:

Prime contractor:

Location:

Date built:

Photographer:

Date of photo:

and so on.

In cases like this, it may also be advantageous to have certain items or aspects of the images cataloged that can simply be checked off:

Views:

[] general [] front [] side [] back

[] aerial/vert. [] aerial/obl. [] interior

[] details/ext. [] details/int. [] plans

This "check-off" group would also be applicable to an architectural library. Similar breakdowns could probably be made for most specific subject areas—depending on the aspects of interest to the collection's users. Where it is possible to apply such a system, it has the dual advantages of clarity in presentation of information to the user and of saving substantial time and effort in cataloging.

Unfortunately, even the use of such a system does not eliminate the need for subject knowledge on the part of the cataloger. While it may be reasonably simple to determine the difference between a front view and an oblique aerial view, the cataloger would still need to have some knowledge of architectural styles, construction techniques, etc., if it is desirable to be able to retrieve by these. In addition, considerable research in reference sources may be necessary to determine the architect of a particular structure or the approximate date of a photograph, if photographs are acquired without complete data.

Nothing precludes the use of an alternate type of description for part of a collection and the paragraph form for other parts. If the same system of assigning access points is used for both methods of description, both types of records can easily be integrated in a catalog.

Another alternative is using some type of verbal description along with a photographic image on each catalog card (where cards are used) or at each access point (in the case of microfilm or microfiche catalogs). We'll

leave videodisk storage of images for the later chapters on computers and other new technology. While using images in conjunction with catalog records (as opposed to image-only access, such as with contact sheets) substantially increases the cataloging costs, and the job of creating and maintaining the catalog, the advantages may be worth it.

This system is often used for collections of historical images where prints are custom-made for users from highly valuable original negatives or even original glass plates. Since letting the user browse through negatives may be impractical because of possible damage, some other access by image is the only alternative allowing the user to know what he is getting.

Libraries of governmental agencies (including international governmental organizations such as the United Nations) have been among the chief users of image-bearing catalog records. Some of these have custom-built or have had custom-designed sophisticated equipment for the reproduction of these records, even with color images. This is also one of the main reasons a few libraries have opted for a larger format catalog card than the standard 12.5 by 7.5 cm size.

All of which still leaves us with the question of how to provide the best possible access points—bringing us to the tracings, which come last in the standard catalog record. Here, too, there is an opportunity to customize while still taking advantage of established systems which we'll explore in the next chapter.

CHOOSING NAME

AND TOPICAL

SUBJECT HEADINGS

Applied Subject Cataloging

A trio of concepts that aren't all that difficult to grasp is the key to a workable catalog—along with a lot of judgment and some policies that you'll have to make up to fit your own collection. First though, an overview of these three concepts, which bring together some of the things we've already been talking about:

—Authority
—Establishing entries
—Verification of entries

AUTHORITY

Authority simply refers to whose word you take for the form of your headings or access points. In most cases, this isn't a matter of simply being able to look up something, but rather a multi-step logical process. For instance, let's say we accept the Library of Congress Subject Heading system as our over-all authority for the formulation of subject headings. For name subject headings (persons, organizations, meetings, and geographic headings which coincide with governmental jurisdictions) LCSH defers to AACR2. It specifies that where there is a choice among alternate names or alternate forms of names and there is no one predominant name, you need to consult reference sources. AACR2 even suggests specific reference sources for some types of headings, such as certain encyclopedias.

For well-known people, one of those reference sources may be *Who's Who*—either the American, British, or other applicable edition. In such cases *Who's Who* is your authority for the choice of the form of name. For less well-known people, other directories can serve as authorities, too—directories of professional organizations to which the person belongs, even telephone directories.

Don't get me wrong. Cataloging isn't a lot of digging around in reference sources, though they can be enormously helpful in some situations. The complex hierarchy of reference sources is only for those sticky situations when you just can't decide. More important than which heading you choose is to go ahead and make the choice—and then consistently use that same form. We've already seen the problems we could run into with the choice between "Carter, Jimmy" and "Carter, James Earl." But even here we wouldn't have to resort to reference sources since the man's preference is clearly known.

Let's look at a situation more typical of my own collection: Railroads frequently paint one name on their rolling stock—often a short catchy name—but legally have another, somewhat longer one. For instance, there's that outfit that in 1971 took over running most of the long-distance passenger trains in the United States. Legally, it's known as the National Railroad Passenger Corp.; the name on the locomotives and cars is Amtrak.

For information on U.S. railroads, I use a publication called the *Official Guide of the Railways*, or just the *Official Guide* in railroad circles. It lists railroads the way they want to be listed and is my authority for U.S. railroad names, which is why the subject heading is Amtrak in my catalog. This is also an application of an AACR2 rule which specifies that where an organization has a short "conventional" name by which it's best known, that name should be used as the heading, rather than its full legal name. Library of Congress also uses "Amtrak" as its heading.

For foreign railroads, either *Jane's World Railways* or the *World Atlas of Railways* edited by O.S. Nock supplies the name in the vernacular.

ESTABLISHING ENTRIES

The whole process of applying our authorities to come up with the correct form of the heading and getting it into the catalog for the first time is known as "establishing" that heading.

Of course, even for those rare cases of alternate names, we don't want to go through the whole process of checking reference sources because we can't remember if we should use the heading National Railroad Passenger Corp. or the heading Amtrak. As the catalog gets larger and larger, you may not remember which heading you used the last time, or, in fact, whether you've ever used a heading for a particular person or organization before at all. For a very large collection, there may be several catalogers

adding records. Obviously, we want to assure that when two people assign a heading for a particular entity, they come up with the same heading. We can set up a local policy that certain reference sources take precedence over others and that once we find a listing in a particular one in our sequential list, we stop and use that form. Sometimes, however, even reference sources are inconclusive, and some people and organizations simply aren't in any reference sources. When there's a choice of two forms of a name to use in a heading and the rules of precedence in AACR2 aren't any help, you simply take your best shot.

VERIFYING ENTRIES

The only way to assure that you come up with the same form of the heading on later records is to *make the catalog itself the top authority.* It becomes the first place you check before assigning any heading over which there is any doubt. For this to work, you may need to make cross references from any alternate forms the first time a heading is used. Libraries put making of cross references in the category of "authority work."

In the library community, there's an important distinction between additional access points on a catalog record, which may bring out various aspects of the material cataloged and cross references. Cross references, sometimes also written as "x-refs," are links from alternate forms of a single heading to the valid form of that heading. A cross reference from a particular alternate form to a particular valid form would occur only once in the catalog; the valid heading, on the other hand, may occur on any number of catalog records. (I've seen any number of articles in photo magazines where someone tries to describe his scheme for organizing materials and refers to added access points as "cross references." They're not.)

So, in assigning a heading for an organization, the name of which (for our catalog) may be either "National Railroad Passenger Corp." or "Amtrak," if we look under "National Railroad Passenger Corp." in our catalog, we should find a cross reference that says:

> National Railroad Passenger Corp.
> see
> Amtrak.

Larger libraries generally maintain separate authority files. These files, whether in computer or card form, list under each valid heading the references made for that heading. Of course, the files also contain all these cross references, so that anyone looking under an alternate form of name would be sent to the valid form of the heading. In addition, these authority records usually carry information on the cataloger who established the heading, when the heading was established, and brief notations as to the sources used in establishing a particular form.

When we assign a heading for use on a catalog record representing a

particular image or group of images, we begin by selecting a probable form of heading. This is then verified against your authority structure: first you check the catalog (or separate authority file, if you go that far), then consult other reference sources in whatever order you've selected for headings in that particular subject area.

So far, our discussion has centered on name headings, which constitute a major part of the LCSH system. The other part, topical headings, pose a different problem—specificity.

The general rule of subject cataloging is to assign the most specific topical heading available, though in some cases several topical headings may be required to give adequate subject access.

This rule of specificity would mean that for a book about lions or a collection of images of lions (or a single lion), the heading assigned would be:
> Lions.

not both that heading and
> Animals.

The problem is that often a search of a catalog is not just for a very specific topic but for a much more general category. A wildlife magazine may want only pictures of lions, but a greeting card publisher's needs may be much more general, with any kind of attractive pictures of animals being acceptable.

If we assign only the most specific subject—"Lions"—how do we find all the pictures of animals in the catalog? Well, I've mentioned before that there are actually two LC subject heading lists—the general (the one for books, etc.) list, and the picture subject heading list—and this is a good place to discuss the differences between the two.

THE LIBRARY OF CONGRESS PICTURE SUBJECT HEADING LIST

The main difference is that the picture headings (the actual title is *Subject Headings Used in the Library of Congress Prints and Photographs Division*) are much more hierarchical—in other words more of a classification system. Whereas in the main LCSH list, "Lions" is a good heading, in the picture list, the valid form of heading is:
> Animals—Lions.

So, by looking under "Animals," we would find not only images or groups of images containing several kinds of animals together, but also images of specific animals:
> Animals.
> Animals—Cats.
> Animals—Dogs.
> Animals—Lions.

While this does have some advantages, it also has some drawbacks. The most obvious drawback is that you have to know to look under the proper general category to find the specific topic. In some areas the general category is not as obvious as it is with lions being part of animals. Of course, the picture headings list does contain cross references, so that under "Lions" there is a see reference showing that the proper heading is "Animals—Lions."

Two other considerations also affect the choice of which list you want to use: the picture list was out of print in late 1985 and its availability is much more limited than the general LCSH list which is printed in large numbers (the 10th edition of the general LCSH—in book form— was in preparation at the same time, while the 9th edition was still in print). Also the picture subject list only represents subjects in LC picture collections, just as the general LCSH topical list represents only subjects of books cataloged by LC. However, though the general list includes many non-pictorial topics (Philosophy, etc.) it is much more extensive, even if these non-visual subjects are excluded.

Basically, then, the main question is whether you would more frequently need to retrieve items from your collection by general categories or by specific topics. If the balance is toward most searches being for specific topics, the general LCSH list is probably more useful.

Both topical lists provide some internal linkages that help you go from general to specific and back again. The general LCSH includes a note under "Flowers" to "see also . . . names of flowers, e.g., Carnations, Roses, Violets." Under "Motor vehicles" there's a "see also" to several narrower and related categories, including "Automobiles." "See alsos" are links to other valid headings, where see references are links from an invalid alternate form to the valid form.

Unlike the case with references for name headings, with topical headings you can probably get away without making references within the catalog itself for topical headings. Remember, all the work that goes into a catalog costs you something—even if it's only your time. Because topical headings have links not only from alternate headings for the same topic but also among various valid headings, the authority work can be quite complex.

An alternative then is to keep the authority structure external to the catalog. Someone looking under "Cars" and not finding anything would then have to consult the LCSH list (either book or microfiche form), where he would quickly find a see reference from "Cars" to "Automobiles." Then it's just a matter of looking again in the catalog, this time under "Automobiles."

How often would you really be retrieving things by very broad subject categories, as opposed to specific topics? I decided that in my case, not very often. And that was one of my primary reasons for going with the

general LCSH list. In some cases where I think I may want to retrieve by a broader category, I simply use both the specific topical heading and the next broader one. Occasionally, I have to assign only the broader category, because I really don't have the expertise to determine what the specific topic would be. If I photograph interesting wildflowers somewhere, I generally assign the heading "Flowers" rather than investing a lot of time trying to determine what specific kinds of flowers these were, because for my specific collection, flowers are not that important a subject. People who contact me are very unlikely to be looking for a picture of a specific type of flower. More likely flowers would be used to illustrate the scenic beauty of a particular place, in which case I always have access by location, anyway.

Which brings us to a final word about reference sources in this chapter. I've already mentioned that for geographic locations that coincide with governmental jurisdictions (states, counties, cities, etc.), the headings are formulated according to rules in AACR2. For geographic features that do not coincide with governmental jurisdictions—rivers, mountains, etc.— there are additional rules as part of the LCSH system, particularly relating to inverting names beginning with generic terms (river, lake, cape, etc.) and the addition of qualifiers to distinguish similarly named features in different places. So, it would be

McKinley, Mount (Alaska)

not "Mount McKinley" and

Sinai Peninsula (Egypt)

since, in both cases, the features are entirely within a state or country.

For a photographer who travels, the most useful reference sources are probably good maps and/or a good atlas depicting the locations photographed.

Maps not only help to identify locations—where the pictures were actually made—but also to verify spellings of place names as well as to provide other data for cataloging and captioning. If possible, get up to date maps produced by government agencies—a map produced by a state's transportation department is preferable to an oil company's travel map, since the former is more likely to be up to date and contain the official spelling of place names. As far as I know, all U.S. states have some type of agency that produces an official map, generally provided free to anyone who requests it.

What if the subjects in your picture collection are so specialized that LCSH is of little help? Options include further subdividing existing LCSH headings, either topically or geographically (where LCSH does not autho-

rize geographic subdivision), and designing your own first-order topical headings.

Wherever possible, further topical division of an existing heading should use the preferred terminology found elsewhere in LCSH. For instance, I have photos showing various commodities being shipped by railroads. "Railroads—Freight" is a good heading on the LCSH list. To bring out specific types of freight, I subdivide, using other valid headings.

"Railroads—Freight—Automobiles"

You can also create your own free-float list to use under existing topics. Designing your own first-order topical headings should be left as a last resort. Even here, you can usually follow the general style of LCSH, once you have selected a preferred term among those available. Consult reference books to help you make these decisions.

CATALOG CARD

REPRODUCTION

From One, Many

Producing cataloging cards to file under each record's access points may at first look like one of cataloging's most perplexing problems—once you decide that a card catalog is the way you want to go. Actually, it's one of the simplest to solve.

There are a multitude of solutions, some admittedly more efficient (and slightly more expensive) than others. The simplest but also the most time consuming is to type (or write) the same information over for each of the cards you need—one for the shelflist, one for each of the subject access points, and one for each of the "author" access points, if you decide to make the latter. If you aren't adding records at a very fast rate and if you aren't assigning very many access points per catalog record, this may even work. The first few hundred cards for my own catalog were done this way while I was trying out some things and deciding on the standards I would use.

Sooner or later, however, you realize that what you really want to do is provide access to images—and that building a card catalog is not an end in itself. Why spend time typing cards that could be better spent producing new images or marketing the images you already have? Once the basic cataloging record has been formulated, the typing of cards to file under various access points requires less intellectual work than the cataloging itself. But even if you have clerical help, that assistance can

be put to more productive use. So the question becomes how to efficiently duplicate the necessary information.

First, let's rule out one method that may come to mind: using carbon copies. Making carbons works only with relatively thin paper stock for a limited number of copies, and carbon copies smudge very easily. None of these factors are condusive to the establishment of a permanent catalog. Once you start a catalog, you'll be making quite a lot of use of it, and you'll want it to last just as long as the collection of photographic images that it represents.

Other options are producing multiple originals or producing one master record that is duplicated through any one of a number of mechanical processes.

WORD PROCESSING

Most modern offices (and even a few homes) are now equipped with typewriters or word processing systems which have memories sufficient to store the approximately 600–700 typewritten (elite size or 12 pitch) characters that would fit on a 12.5 x 7.5 cm (approximately 3 x 5 inch) standard catalog card. These systems have the advantage of storing letter-perfect information in the memory. Once the information is in the memory, these automatic typewriters can type a card at incredible speed as many times as you need it. At 120 words a minute most cards take less than a minute.

You would still have to feed cards into the "printer" or typing unit of the word processing system, but even this function can be speeded up. Most large library supply houses sell cards in continuous perforated fan-fold strips for just such applications.

Of course, these word processing systems are expensive. We're talking about something beginning at a minimum of about $2,000—and only the sky is the limit. But if you have access to one, why not use it?

Even with most simpler word processing systems, however, you still need to have some way of designating under which access point a particular copy of a catalog record should be filed. If you use the dropped heading system described in a later chapter, it's just a matter of checking off or underlining the proper heading. But this system is more bothersome if catalog records typically run longer than one card, and it requires you to make guide cards for efficient use of the catalog.

If you use overtyped headings, you still need to manually overtype each heading. Word processing systems are simply special purpose computers. The more sophisticated ones are closer to true general-purpose computers in that they can be user-programmed to perform special functions.

If we use a computer, we can get the computer to do the overtyping, too. Once the basic record has been created, the computer can overtype

the headings on each card—that is if it has been programmed to perform this function and if the access points in the basic record have been coded in such a way that the computer can recognize where the access point heading begins and ends. Again, buying a computer to print catalog cards is hardly a wise investment. But computers can do much more—including the elimination of the card catalog altogether; that, however, remains for discussion in another chapter.

For now, let's look at some of the options left for those of us who can't afford a computer yet. These are going to be some type of mechanical reproduction—either done by yourself or by someone else for you. These methods can range from a spirit duplicator or a mimeograph stencil to offset printing, with use of photocopying machines (Xerox and other brands) somewhere in between.

Some of the basic considerations are cost, quality of reproduction and permanence of the reproduced cards.

OFFSET PRINTING

If you consider all these factors, then offset printing is well worth considering. And don't immediately jump to the conclusion that this is going to cost you an arm and a leg.

This method has been used by many large libraries, including major university libraries, for many years. Although many of these now use computer-produced cards for their catalogs, they've usually kept the necessary equipment for producing cards in nonroman alphabet scripts (which can't be handled by computer printers), information cards, and special forms for local processing files.

Many libraries that have these facilities will provide card duplication services to outsiders—either at cost or a nominal fee. Libraries generally are not in the profit-making business. On the other hand they don't advertise this service either. It's worth checking libraries in your area to see what they have in the way of card reproduction equipment and whether they would consider doing this work for you. Libraries often have special equipment for making offset masters and have presses which can precisely run small numbers of copies and which automatically change masters.

Offset printing, while certainly a quality reproduction method, may not appear to be an efficient method of reproducing 3 x 5 inch cards. It wouldn't be for individual cards, but the usual practice is to run off sheets of ten cards at a time. The cards are printed on special cardstock sheets which are already punched for catalog drawer rods. After being run off, the sheets are then cut into stacks of individual cards.

Since you will be charged either per sheet or per card, the logical thing to do is group together batches of 10 cards all requiring the same number

of access points—in other words, requiring the same number of copies. If an occasional card requires far more than the usual number of access points, it may be worth having that particular card run twice, with only part of the total being done in each batch.

Suppose that you normally require five to seven copies of each card. Then you would normally have seven sheets of cards run from each master. If suddenly you need 13 copies of one card, it would hardly be logical to have 13 sheets run if you only need seven copies of the other nine cards on the sheet. You would end up with—and end up paying for—at least 56 extra useless cards. So, the logical thing is to include this particular card on two masters, each of which is having seven copies run, giving a total very close to the required number of cards.

There are also some commercial card duplicating services which advertise from time to time in library periodicals. You may want to check the ads in some of the publications listed in the bibliography at the back of this book.

A couple of very important considerations if you're going to have cards reproduced by someone else—you may have noted that I have generally used the metric designation 12.5 x 7.5 cm, rather than 3 x 5 inches. The difference for a single card is minute; however, when you group ten cards together, the difference is significant. And the four, six, eight, or ten card sheets sold by library suppliers are in metric sizes. That difference could be enough to result in some vital information going off one of the edges of one of your cards.

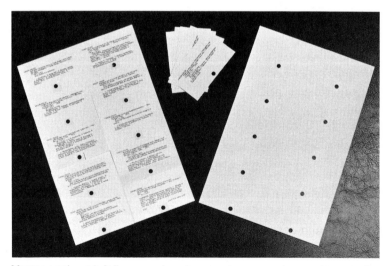

Master cards, at left (here produced on a microcomputer word-processing system, but you can also create them on any typewriter) are pasted up on a master sheet . . . which is then used to make an offset master to print onto blank sheets like the one at right. The cards produced by this method, shown at the center, are then cut apart for individual overtyping.

For the same reason, whether you write or type the cards that you have reproduced, leave a safety margin of at least one-quarter to one-third inch all around your cards (and in the area of the rod hole). The best maintained and operated presses can get slightly out of alignment.

And, finally, if you send your catalog cards off for reproduction, particularly if you send them by mail to a commercial concern, make at least one photocopy of the information on them. If the originals are lost, it is easy to type another copy. The major cost and investment in the cards is, after all, not in the cardstock but in the intellectual effort of cataloging: preparing the description and access points.

If there isn't a library in your area that can or will reproduce cards for you, check out small local printers to see if they could handle this service for you at a reasonable cost. Shops that specialize in "instant printing" (such as the PIP franchises) would be good candidates. You may need to make the printer aware of the availability of 10-card catalog card sheets; in fact, if you are the only customer using this stock, you may have to spring for a shipment of a couple hundred of these sheets up front. They're available from most distributors of library supplies.

PHOTOCOPIES AND MIMEOGRAPHS
If this method isn't available or doesn't appeal to you, there are still several mechanical processes left. One of these is the "plain paper" photocopier (Xerox and various other brands). Not all photocopiers can handle this, but many of the heavy-duty models used by commercial copy shops can handle odd-sized stock—and cardstock at that.

Again, the idea is to run off several cards at once. Library supply houses sell four-card and six-card sheets for these purposes, some perforated so that you can simply pull them apart after they've been through the machine. Try to get the supplier to send you a couple of sample sheets to try out on the photocopier available to you before you invest in a large supply.

Finally, if you don't have access to a copying machine, and if you only need a limited number of cards, you may want to consider duplicating cards yourself at your home or office. Library suppliers sell gadgets (in the $50 range) that use mimeograph stencils. These will run only one card at a time and can be somewhat messy since you have to re-ink and clean them, but they're still better than individually typing or writing a card for each access point. In addition to reproducing information on catalog cards, these gadgets can also be used to reproduce the same message on a number of postcards—which can be put to a variety of personal and business uses.

All together there are quite a few options. Look at some of the journals aimed at librarians for library supply house addresses and write them for

their catalogs. You may find a variety of other supplies and equipment that will provide assistance in this area of organizing. Many of these suppliers are used to dealing with both large and small customers (there are quite a few very small public and corporate libraries). They will sell supplies in very small quantities, and may even accept orders billed to your Visa or Master Card account.

Whether you start your catalog in a tiny file box or even a shoe box, I cannot stress enough the importance of using "real" catalog cards from the beginning. By this I mean catalog cards that are printed on some type of reasonably permanent stock that will stand up to repeated handling and will not smudge easily—and that are punched for a rod hole.

To get these, you will probably have to order catalog cards from a library supplier, since the "index cards" offered by the typical office supply store hardly fit the bill. The rod hole at the bottom of the card—though it will cost you a little usable text space—is actually one of the more important features.

CARD CATALOG CABINETS

Depending on the actual weight of cardstock used, a catalog drawer will hold somewhere around a hundred or more cards per inch. Since the drawers of most catalog cabinets will hold about 15 inches of cards, this means that at some point the drawer will hold upwards of a thousand cards. And those drawers will get handled a good bit.

Unless you can afford a couple of hours refiling these cards after a drawer has been dumped or dropped, the rod that goes through the bottom of the cards and locks them in place is indispensable. It's pulled out only for a few moments to add new cards—while the drawer is resting on a flat firm surface—then is immediately replaced to lock the cards in place.

By now you may also have noticed that your average "index card" box doesn't come with a locking rod for your cards—that you'll have to spring for a "real" card catalog cabinet sooner or later. It doesn't have to be your first investment, however.

Where do you get one of these? If you either don't care too much what the cabinet looks like or are reasonably handy at wood refinishing, you can probably pick up used wooden cabinets, either from a local library or at a flea market. You should be able to get these at quite reasonable prices as more and more libraries convert some of their files to large computer systems.

If you would rather get a new cabinet, then the major library suppliers (you can get addresses from which to request their price lists and catalogs from most of the larger library trade magazines) will be happy to sell

you cabinets ranging from one or two drawers up to hundreds, made of anything from sheet metal and molded heavy duty plastic to the finest mahogany wood.

Keep in mind that these cabinets should last a very long time, and that if you buy the best wooden ones, they'll cost you as much as any piece of fine furniture. I bought a six-drawer unit of heavy molded plastic a number of years ago, which has served quite well—and which should continue to serve for a number of years before I run out of space.

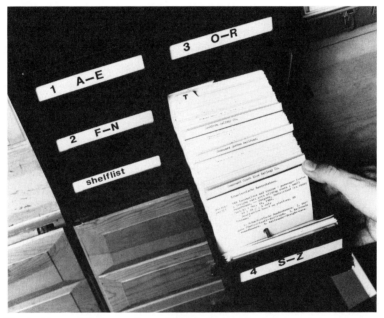

The locking rod that goes through the bottoms of catalog cards is an important feature of card catalog cabinets, because it prevents you from spending hours re-sorting a spilled tray of cards. Guide cards show where major subject groups and various parts of the alphabet begin.

ORGANIZING YOUR
CATALOG RECORDS

You Can Get There from Here—
If You Really Try

Now that we've figured out how to clone one card into many to give us the necessary access points, it's just a matter of getting all the cards in alphabetical order, and we'll live happily ever after. Right? Wrong.

Life in catalogland isn't quite that simple. On the other hand, neither are the problems incurable. For instance, let's look at this group of possible access points on a variety of cataloging records:

Paris (France)
Paris, Xavier J.
Paris-Smith, Edward.
Paris Widget Corp.
Paris (France). Pavillion des arts.
Paris (France)—Maps.
Paris (France)—Bridges.
Paris, Frances Joan.
Paris, Annie.
Paris (France). Conseil.
Paris family.

Now, we can arrange these strictly alphabetically, word-by-word, if we can agree what a word is. Let us, for the sake of argument, define words as simply groups of characters without any blank spaces in their midst. Dashes count as word-separators, the same as spaces; hyphens do, too. Fine. Now the list would look like this:

> Paris, Annie.
> Paris family.
> Paris (France)
> Paris (France)—Bridges.
> Paris (France). Conseil.
> Paris (France)—Maps.
> Paris (France). Pavillion des arts.
> Paris, Frances Joan.
> Paris-Smith, Edward.
> Paris Widget Corp.
> Paris, Xavier J.

The advantage of this system is that it's relatively easy to learn or to program on a computer. And, because the ability to process information by computer is not among the least of considerations, this type of system is the one now used by many libraries.

(In case you were thinking that having your catalog on a computer would solve these problems, consider this: A very desirable feature on computer databases is being able to do "truncated searches." That means that you supply only the beginning word or words or, in some cases, only a few characters at the beginning of a word, and the computer shows you all the responses that begin with the specified word(s) or characters. In such a situation you would want the computer to be able to display a summary of all the responses that match your inquiry. You would also want the computer to be able to arrange those responses in some logical manner.)

While the above arrangement is easy to learn, it leaves something to be desired in terms of logical grouping. To find all the members of the Paris family, for instance, you have to look past the Paris, France, listings and organizations that begin with the same word, such as Paris Widget Corp. Also, units of the Paris city government which are entered hierarchically under Paris—the ones with the period and two spaces in the middle—are interfiled with topical subdivisions of Paris—the ones with the dashes in the middle.

FILING RULES AND GUIDELINES

Only a few years ago, most libraries used a much more complex set of filing rules which would have arranged the above list in the following order:

Paris, Annie.
Paris, Frances Joan.
Paris, Xavier J.
Paris family.
Paris-Smith, Edward.
Paris (France)
Paris (France)—Bridges.
Paris (France)—Maps.
Paris (France). Conseil.
Paris (France). Pavillion des arts.
Paris Widget Corp.

This set of filing rules is based on the order of precedence of "people, places, things," with some other additions. Compound surnames file at the end of all the single surnames beginning with the same word. Topical subdivisions of a name heading come ahead of all subsidiary organizations. Organizations come after all the places that begin with the same word. Although these rules offer some advantages in the arrangement of these headings, they are difficult to teach and to apply in using the catalog.

This is an area where you'll find disparity among libraries, since the filing arrangement within a local catalog has no effect on other libraries. The closest thing to a national standard is a booklet published by the American Library Association (ALA) containing recommendations for filing rules with various options and modifications.

The latest edition of the ALA filing rules is essentially the simpler word-by-word method. Still, you'll find many catalogs using the older "people, places, things" rules, partly because once you have thousands of cards in a catalog, attempting to refile them according to a new set of rules becomes prohibitively expensive. Things are confusing enough without having two or more sets of rules applied within the same catalog.

Under the newest rules, numbers are treated as words (instead of filing according to the form they would represent if they were spelled out), and these numbers file ahead of any letters: So, "13–30 Corp." would file ahead of "Aardvark Enterprises." This eliminates the problem of trying to figure out whether numbers should be translated into their English equivalent or into another language if a foreign organization is involved.

So far, we've only looked at how we arrange different headings. In the catalog of any collection, you will quickly reach the point where you have several records which use the same heading. Here you have another difference between picture collections and book libraries. In book libraries, the cards for several books about Mark Twain (or, "Twain, Mark.") would be subfiled by author. And, we've already seen that for many catalogs of individual picture collections, "author" is not a useful access point— and is something that we would normally dispense with in the description.

However, where there are cataloging records for different editions of the same work (same author, same title, same subject, but different date of publication), the subject cards after author and title are subfiled by date of publication. Now, we're getting to something more useful for pictures. If we have two cards, both overtyped with the subject heading "Doe, John," the most logical sub-arrangement of those cards is by date. That way, the catalog provides you a chronological arrangement of each particular subject heading. If you use an accession numbering system for the addresses you assign to images you've made yourself, then those would work just as well, since numbers assigned in the same sequence in which images are added should also reflect the chronological sequence in which the photos were made.

If the most recent photos of any particular subject are likely to be of the most interest for users of a particular collection, you may even want to opt for reverse chronological order in filing—cards for the newest items at the front with oldest records at the back.

Of course, there are likely to be a lot more than just cataloging records in your catalog. We've already seen the need for at least some cross references—even if we rely on a copy of LCSH topical headings next to the catalog. But, probably the first thing you'll want as an addition to your first few catalog cards are some guidecards. These are simply cards that stick up above the rest of the catalog cards to help you find your place in the file more quickly.

In the beginning, cards showing where each letter of the alphabet begins in the subject file and cards indicating the major divisions in the shelflist—by year if an accession numbering system is used—will do. Later you'll want some indication of the beginnings of major subject areas to help you find those more quickly.

I use guidecards at the beginning not only of "Railroads" but also of the headings for the major railroad companies, as well as "Austria" and "North Carolina"—the major areas of my collection.

This is a good point to explain the major alternative to overtyping headings—a system called "dropped headings." Here, once an adequate number of copies of each cataloging record have been reproduced, each heading in the tracings is simply marked, in turn, usually by underlining, to indicate where it should be filed. Then, the first time each heading is used, a guidecard is made for that heading. (Yes, this system requires that guidecards are made for each and every heading, though there will usually be multiple cards with the same heading filed behind each guidecard after a while.) Essentially, it's a trade-off between making the guidecards which eat up extra space in the catalog, and the overtyping of individual cards.

One thing worth noting: when the only indication of where a card should be filed is an underlined heading at the bottom of the card, it's

easy for cards to get filed in the wrong place. And a misfiled card means loss of access. Correct filing is such an important factor in the building of a catalog that most large libraries do it as a two-step process. One person files cards, "above the rod" into the catalog drawer. A second person checks the correctness of the filing, and then, once that is verified, pulls out the rod, drops the new cards in place and locks them in by replacing the rod.

The possibility of filing cards in the wrong place increases with the size of the over-all catalog and the number of cards being filed at one time. It's not unusual for a whole group of cards to be misfiled, so that after a while simply checking that a card fits correctly between the card in front and behind no longer shows that all of them are out of sequence.

Another question of trade-offs is whether you need the entire cataloging record at every access point for records that run more than one card. Do you really need the tracings on card 2 under a particular subject heading, if the tracings are the only information on that second card? How about notes that appear on the second or third of a multi-card record?

On the one hand, having skeleton information at each access point—with the full record only in the shelflist—saves on reproduction and over-typing of cards and growth of the catalog while still giving access to the desired material. On the other hand, the tracings often can give you additional headings to look under for related material if you don't find what you want. Besides there's something aesthetically pleasing about having the same completeness for all the cataloging records, since the shorter records that fit on one card will have the tracings present. (I initially used skeleton cards for the longer records when I was having the cards reproduced for me; now that I use my computer to produce cards, it's reasonably simple to have full records in all locations.)

SEE ALSO REFERENCES
Ultimately, however, the major decision in organizing a catalog is how much linkage to provide in the form of see also references to related topics. That decision can be made only by looking at who will be using that catalog.

A basic principle that has been followed in North American subject cataloging practice—following the policies set by the Library of Congress—is to assign the narrowest possible subject headings available to provide adequate coverage, though where that is a name subject heading, a topical heading is also used. (For example, for a book about John Doe, novelist, the headings used by LC would typically be 1. Doe, John. 2. Novelists, American.)

Now, there's also a good heading, "Authors" and there are provisions for authors of specific nationalities, such as "Authors, American." If Sally

Smith writes in a variety of areas, producing plays, novels, and poetry, the more appropriate topical heading for her would be "Authors, American." However, someone looking under "Authors, American" to find all the possible books about American authors (or all possible pictures of American authors in the case of our picture catalog) would need to know that he also needs to look under specific types of American authors. Under "Authors, American," LCSH provides a note to "see also: . . . particular classes of writers, e.g., Dramatists, Historians, Humorists, Novelists, Poets."

The advantage of this system of linking from broader topics to narrower topics is that a reference needs to be made but once, and only one card needs to be filed under one topical heading for each record, instead of cards for various levels of the topical hierarchy for each record.

The problem is that keeping up with all these see also references is a lot of work. As already mentioned, we can use the availability of the LCSH thesaurus, in either book or fiche form, as an alternative to actually putting topical references in the catalog. The catalog user just has to know about the help that LCSH can provide, either to get to the form of heading that he should be looking under (in case he's starting with an invalid form) or to related topical headings.

The first case is usually a lot more obvious than the second. If you don't find anything in a catalog under what you think should be an access point, you're likely to find out where else you could look. However, if you do find something at a particular access point, it's much harder to remember that there may be related, equally useful material under another related heading.

In the end, there's no substitute for someone who knows the collection. Libraries employ reference librarians not only to look things up for you, but also to give you pointers on how to find what you're looking for, even if there's no direct access point in the catalog.

As we've already seen in the discussion of cataloging and assigning access points, it's often impossible to assign an access point for everything that may be of significance in an image. By knowing your collection—or at least having one person who keeps an overview of what's going into the collection—it's still possible to retrieve the wanted images.

When Kalbach Books wanted a photo of a BQ23-7 GE locomotive for the cover of a book on locomotive types, I was able to find a selection of images (one of which did appear on the cover) by remembering where I had photographed this type of locomotive, though I generally do not provide access points by specific locomotive type. I could equally well have found the images by remembering when the images were made, and locating them through the shelflist.

STORING AND USING YOUR COLLECTION

STORAGE AND HANDLING

TECHNIQUES

Now That You've Got It,
Where Do You Put It?

All libraries have two diametrically opposed and almost irre-
concilable missions: to preserve their contents and to make
them as accessible as possible for maximum use. Nowhere
is this more true than with picture libraries.

Each time a negative or transparency is handled brings with it the possi-
bility of scratches or fingerprints permanently marring the image. Prints,
too, are susceptible to abrasion, cracking and staining.

Color materials are particularly vulnerable, with every exposure to light
contributing to the ultimate fading of the dyes used, though for modern
color materials that process can take many years with a few reasonable
precautions.

To attempt to permanently preserve a color transparency (without resort-
ing to black and white separations which would have to be re-combined
at a later time to provide a viewable image) some experts would advise
you to seal it in a moisture- and dust-proof enclosure and then to store
that at a constant, cool temperature—in total darkness. But even here,
opinions vary as to the type of enclosure and the specific temperature.

After all, there are very few transparencies that have been around for
50 years, and while it's possible to simulate the effects of time at an
accelerated pace in the laboratory, that's just not completely the same.
Some emulsion formulations are still relatively new (even such well known

films as Kodachrome and Ektachrome undergo changes in formulation from time to time) and at this point it's difficult to tell if the images will really last the minimum 50 to 75 years that film manufacturers claim—among other reasons, because there are so many variables as to how these images may be stored and used. Few of us can afford to install a giant walk-in refrigerator with precise temperature and humidity controls, for which the Time-Life picture collection has opted to store its most valuable color materials.

The main reason for making photographs is for those images to be viewed—whether that viewing consists of simply projecting them for a few friends or of having them published in a book or magazine. If the prime aim of a picture collection is to bring income to its owner, then speed of access can be an important factor. Purchasers of stock images invariably make requests for submissions just prior to their deadlines and always want things yesterday, if not sooner.

Any overly-elaborate means of preservation which interfere with access are counter-productive because they cost you time in handling material—and in business, time is money. But especially for commercial collections, the safety of each individual image is important, too, because it's not the physical transparency that's sold, but rather the rights to its use. And in most cases, rights to any one image can be sold over and over again, provided that image has not been damaged.

Sometimes a particular image will sit for years in a file, bringing its first income a decade or more after it was made. It now has historic value, because it shows how people dressed, travelled or lived at a particular time. Also, tastes change, both for the population as a whole and among those who edit publications that use pictures, which may make a particular image more useful later.

So, what all of this points out is that the physical arrangement of your collection—your filing system for transparencies, negatives and prints—will involve at least as many compromises as anything else in picture librarianship.

HAZARDS OF STORING FILM AND PRINTS

Where do we begin to address some of the above questions? Probably the best method is by looking at how that collection will be used, and going backwards from there. En route, we'll try to avoid anything that we know is obviously harmful to the images, and concentrate on anything that facilitates both access and offers at least a modest amount of protection.

Unfortunately, there are still companies around that will sell you as a method of slide storage plastic pages that ultimately destroy the very slides they are supposed to protect. These are sleeves containing Polyvinylchlorides (PVCs)—softening agents—which not only keep the plastic pages

soft, but which will start softening up the film base, too. After a while, and not even a long one at that, the sleeve and the film will actually fuse together, making that transparency or negative totally useless.

That doesn't mean that storage of transparencies or negatives in plastic pages may not be the best alternative for your collection, but you need to be careful about what types of plastic pages you use. Unless you can test the chemical composition of these pages yourself, you will have to rely on the reputation of the manufacturer and, better yet, purchase these items only from a vendor specializing in archival supplies.

Untreated wood can give off fumes harmful to color slides, and attempting to paint a metal cabinet used for storage of photographic images can be disastrous, since even months later, that paint, too, can give off chemical gases which can attack your images. (Commercially sold metal storage cabinets generally have baked-on enamel coatings.)

Beware, too, of any paper or plastic sleeves with glued seams. Over time that glue can deteriorate or soak through the material and start attacking the photographic material enclosed. Even the paper enclosure itself can contain sufficient acidity to ultimately damage its contents.

These hazards all threaten even the most modern types of photographic materials. If your collection contains or consists of historic images—from such relatively recent photographic media as glass negatives or lantern slides to products of the early photographic processes, such as daguerreotypes and ambrotypes, then you face special problems beyond the scope of this chapter. Preservation of these types of materials is worthy of a book by itself, and, indeed, there are several good books on the subject, including a manual by the Society of American Archivists. Check the bibliography at the end of this book for further information.

Older film negatives are not without their own problems. The potential for combustion of nitrate films is well known. Less well publicized is the problem with some acetate-based films manufactured up to the 1950s, where, over time the base and emulsion shrink at different rates, causing the emulsion first to wrinkle, then separate from its base. Both effects eventually destroy the negative. Though refrigeration retards the decomposition of both nitrate and acetate films, the process cannot be totally halted, and the only method to preserve these images is to copy them onto some more stable medium.

In dealing with modern materials, we still face a wide range of choices and dilemmas. We want a storage method that gives us at least a moderate amount of protection from light, dust and humidity, and if at all possible, we want the collection to be housed in an area with at least some climatic controls to keep the material moderately cool and avoid major fluctuations in temperature. At the same time, of course, we want rapid access to material in a multitude of formats.

MULTIPLE FORMATS

Happy and lucky is the photographer whose collection consists solely of 35mm transparencies, because he can at least easily standardize on a single method of filing his material—either all in some type of flat file drawers or transparency pages. The slide mounts provide a convenient place to record some minimal information, such as where the images should be filed.

For most collections, even where all of the photography is done in the same format (for instance, 35mm), there will, however, be at least some of the following types of materials: transparencies, negatives, and prints. Chances are that you will need three different types of filing systems for these. That doesn't mean that you can't standardize. In fact, the more you are able to standardize, the easier your arrangement of materials will be.

I shoot not only 35mm (primarily color transparencies, though sometimes black and white negative, and very rarely color negative) but also 6 x 6 cm (primarily black and white negatives, though sometimes also color negative and very rarely color transparencies in this format). So, I have a total of four active files within my collection. The largest is the 35mm transparency file, the second is a negative file, the third a print file, and the final a small file of 6 x 6 cm transparencies.

After experimenting with a number of different means of dealing with negatives, I settled on polyethylene pages in ringbinders, because this method lets me integrate a variety of formats into one filing system. There are pages for 35mm negatives and ones for 6 x 6 cm roll film. Should I ever ever find the need for shooting or acquiring any material in 4 x 5 format, that, too, could easily be integrated into the same file.

Right now, I simply number the pages, each of which holds one roll of film in its respective format, consecutively, regardless of the format. If necessary, individual negatives can easily be referred to by the roll number (which, like my slide numbering system starts with the year) and the frame number.

It's also possible to file negatives in a variety of shallow drawers designed for this purpose—and here, too, you can combine a variety of formats in a single file, though you'll probably be wasting some space since the size of your drawer will be determined by the largest format you use. Within those drawers, however, the negatives will still need to be filed in some type of paper or plastic sleeves, which will need to be labeled or at least numbered. Splitting a 36-exposure film into six individually-sleeved six-frame strips would involve six times as much labeling as for a ring-binder page holding the entire roll.

For prints that I retain (and here I'll emphasize the last three words), I've standardized on the 8 x 10 format. It's what most publications want,

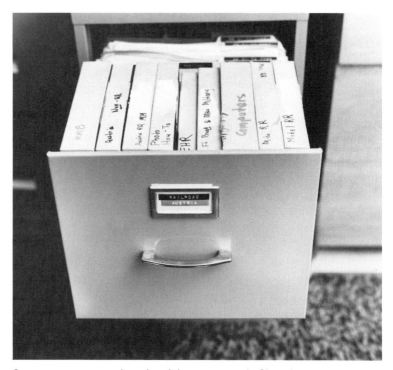

Storage systems need not be elaborate to work. Since I usually keep only a small amount of material in black-and-white print form (most of my current work is in color transparency form), a few recycled print paper boxes labeled with general categories suffice. They fit vertically at the front of standard-size file drawers.

though a few sometimes accept smaller prints. While it would occasionally save me a little money to print 5 x 7s to accompany an article or as a stock submission, in the long run it's a lot easier for me to have to file only prints which are all one size. This doesn't mean that the images are all the same shape; it just means that where I print a particularly oblong or square image on 8 x 10 paper, I just leave additional border space on one side. Of course for display purposes or any other purpose a particular client has, I'll print (or have printed by a custom color lab) to any desired size.

Since most stock-photo markets, or at least the better paying ones, prefer color, and a color image can always be reproduced in black and white, if that's the way the client wants to use it, I shoot color slides—unless there's a very good reason for doing otherwise. So, I end up with very few prints to file, and these are filed by a few general categories in boxes in file cabinets.

Boxes are better than file folders because less pressure is put on the individual prints. Pressure causes abrasion damage to the prints and grinds any surface dirt into the prints. If you can justify it economically, acid-

free containers provide better long-term storage, though this can quickly get very expensive. I use the original boxes the printing paper came in, and put more emphasis on preservation of the negatives.

With transparencies, you have two major choices for storage of large volumes, though there are variations of both: in drawers of some type of cabinet; or in pages. Most manufacturers of slide filing cabinets offer the option of either storing slides in groups or in individual slots (providing either different types of inserts for their drawers or different types of drawers); slide pages can either be stored in ring binders or (with special adapters) hung from rods in suspension type filing cabinets. Some manufacturers also provide cabinets with racks for very large sheets storing several hundred slides per sheet. For the latter, however, you need appropriately large lightboxes to view the slides, and these large sheets are ungainly to handle.

Which method—drawers or sheets—is better? It's largely a matter of preference. When looking at either, remember to consider price and convert that price to a per unit cost. A cabinet costing $400 may appear expensive but will probably provide space for many years worth of slides without additional expense.

For computing the cost of storing slides in sheets, remember that in addition to the sheets, you also need something to keep those sheets in. At a minimum, that involves a ringbinder, though, to give dust protection, that ringbinder should also have a slipcase. Then that ringbinder (with or without its slipcase) will need to be stored in some type of cabinet or bookcase.

Though most buyers of stock photography want submissions of slides in sheets rather than loose in boxes, chances are almost 100 per cent that if you do choose to store slides in sheets, those sheets will not coincide with the sheets you will want to submit, so you will still need to pull (and later re-file) individual slides to put together a selection meeting a particular request.

Filing groups of slides in drawers makes it somewhat easier to indicate the beginning and end of a particular group than it is with slides filed in sheets. Overall, it's also a lot more compact. The latter was among a number of factors that influenced me to go with this filing method.

Some factors to look at if you are considering this method: most manufacturers sell slide storage cabinets in stackable modules of from one to five or six drawers. The units with more drawers are generally better buys as far as per slide storage costs go. If the manufacturer offers two widths of drawers, go with the narrower ones.

There will be times when you will want to remove an entire drawer of slides from the cabinet (particularly if there are several people working with the collection at the same time), and smaller drawers are easier to

Drawers for small items, such as 35mm slides, are difficult to use when they are close to the floor. Instead of paying for a base (available from most manufacturers of these files), a standard file cabinet or other piece of furniture that you already have will usually do.

handle. Ease in handling in turn translates into less likelihood of spilling the contents. And, if part or all of the contents are spilled, there's a lot less to be re-filed.

Drawers should be removable—but only when you want them to be, so there should be some type of stop that prevents a drawer from being accidentally pulled completely out of the cabinet—thereby avoiding many a disaster. (The drawers that I'm currently using, from Luxor Corp., require that a special metal "key" be inserted at the side of the drawer to remove it completely from the cabinet.) The drawers should also give you at least one-quarter to one-half inch clearance above the slides for any guidecards you may want to insert to indicate the beginnings of various groups.

Most manufacturers will list capacities for group slide files. While technically true, they are nevertheless somewhat inflated. A more realistic figure is probably 10 to 20 per cent below the figure given by the manufacturer. The reason for this is that the manufacturer will generally give a figure for the absolute maximum number of slides that can be crammed into a drawer. With the drawer packed to that capacity, it's extremely difficult to remove or insert either individual slides or groups of slides. Also, groups will not always end exactly at the point where the manufacturer has provided a place for insertion of a partition.

What's wrong with this picture? This file drawer contains no guide cards showing the beginnings of various groups. Guide cards greatly speed up the process of locating desired items in the file.

Slides filed in a group filing drawer (this partical-metal model made by Luxor). Guide cards indicate where groups begin. Note that numbering (and filing) runs from the *back* of the drawer to the front. That way, slides are in the correct order for stack-loading viewers or projectors, which normally feed off the bottom of a stack.

The single most important secret to using group files, which I've never seen mentioned anywhere, not even in a manufacturer's catalog, is that the most sensible way of arranging slides is from back to front. The lowest numbered slide goes at the back of the drawer, with higher numbers going toward the front.

Why? Because stack-loading slide viewers and projectors feed from the bottom of a stack! This way, you can take a group of slides, drop them into the viewer, and run them through in the proper sequence. This is one of the fastest ways of viewing a large number of slides.

THE WORKSTATION AND ESSENTIAL TOOLS

Many of the choices connected with storage and viewing systems tie in with the overall design of a work area. Especially for smaller collections, the initial sorting, labeling and cataloging of new images will probably take place in the same area where later on images will be edited together for submissions or programs to be projected. It makes sense for as many of the tools needed for all of these processes to be as handy as possible.

My current work area is in a corner of a room that includes some of my computer equipment. By simply turning in my swivel chair, I can reach not only my card catalog and slide file, but also the computer keyboard and a telephone (mounted under my computer table). Rolling the chair a foot or so to one side, I'm at an area with several square feet of flat work space, complete with light boxes, viewer, and reference materials

A wide-angle view of the corner where I do most of my picture editing, cataloging, and related work. By simply turning in my chair, I have access to my card catalog, light boxes, a stack-loading viewer, my computer, and a major portion of my slide file (in the cabinet under the computer printer in the foreground). Above the work surface and lightbox on the desk are my most-often-used reference sources, including market listings, cataloging rules, and two boxes with maps. A homemade insert holds three 10″ deep boxes for sorting 35mm slides.

(for both cataloging and caption writing) on a bookshelf above. All electrical items are connected through switched outlet strips, so that the flip of a single switch will turn off all the light boxes and the viewer; another switch shuts down the computer and all peripherals. Having a generous supply of electrical outlets should be a key consideration in selecting a work area.

What types of tools do we need at such a workstation? We've already mentioned viewing equipment. A stack-loading viewer helps us go through a large number of transparencies quickly. Light boxes are needed both for editing transparencies and looking at negatives. In addition to some type of viewer, we'll probably also want some high power magnifier for closely checking individual slides or negatives. Don't forget, however, that a lower power magnifier with a wider area of coverage is essential for comparing images, and there'll be numerous situations when you'll need to do that to select the best transparency to submit or negative to print.

A variety of rubber stamps can be used for recording information on transparency mounts and prints. It's well worth the cost of having these custom-made. Other tools may include a hobby knife (X-acto and similar brands) for opening transparency mounts and a tacking iron to seal heat-sensitive cardboard transparency mounts. (In most cases transparencies are removed from their mounts to make separations for publication; you'll need to re-mount and re-label these when they are returned.)

For many of these items, questions of what's adequate and how much to spend can only be answered by the person working with the collection. How much light-box space is adequate? It will depend on the number of people working with the collection, their style of work, and the space available, though enough to handle at least two rolls of transparencies (72 total images) may be a minimum. That will let you sort together images shot alternately with two camera bodies or give you an overview of a much longer sequence in preparing a program for projection.

Going with the biggest light box you can afford or fit into your working area may not be the best choice, especially if you don't have unlimited space. For many tasks a single small light box will suffice, allowing other work space to be converted to other uses. Having a couple of small light boxes rather than one large one also lets some of these be used in another area if needed by another person.

Critical comparisons of images on a light box should always be done with the images side by side, to assure both are receiving the same illumination. When viewing only a small number of images—slides or negatives—on a large light box, strips or sheets of mounting board can be used to mask out part of the illuminated area to cut down on glare and to make viewing easier.

Some light boxes have tracks for holding slides when the viewing surface

is tilted up; others just provide a large flat surface. Both types have their advantages. Do look, however, for fairly even illumination of the entire viewing surface. A box with several incandescent bulbs or flourescent tubes (or one of the circular flourescent tubes) will serve better than one with just a single light source. In the latter case, the brightness may differ by a factor of as much as four from the center of the viewing area to its edges. While a variety of equipment for viewing and editing is available from commercial sources, many of these items, especially light boxes, can also be home-made at considerable savings, allowing you to customize your equipment to your space requirements.

Of course, as soon as you get your images neatly and orderly arranged, it will be time to pull some of them from the files to use them. The question of how we keep track of those images brings us to the subject of "circulation."

CIRCULATION SYSTEMS
FOR PICTURES

If It's Not Where It's Supposed to Be,
Where Is It?

The purpose of organizing your images is to be able to use them. And any images that are in use aren't going to be where our catalog says they are.

Keeping track of these items means that we need some type of circulation system—just like the book libraries—where items are checked out and then checked back in. At a minimum, we'll want to know where the item is if it's not in the file. It may have been included in a submission to a publication, or it may simply have been used in a program that's still in a Carousel tray after being projected.

Circulation doesn't have to be external. For instance, you may choose to keep your prize photo of the UFO landing in the town square in your fireproof safe, rather than in the same file as all the other transparencies, but, if that particular image is numbered in the same sequence as all your other transparencies, you need to indicate where the item with that number is for those who look for it in the main file.

Book libraries are normally concerned with at least two kinds of information for any item away from its shelving location. Who has it, meaning where is it? And, how long has it been gone?

With a typical manual circulation system, this may involve filling out a slip with two carbon copies. The first copy is filed by call number (shelving address); the second by date (either the date out or the date due back, depending on the system used); and the third copy stays with the

item both to remind the person having it when it's due back and (as we'll see in a moment) to clear the date file when the item is returned.

Filing the first copy by call number lets a librarian determine where the item is (and when it should be back) when a patron asks for it after not being able to find it on the shelf. The date file is aged a specified period of time and is then used to generate a reminder note for the patron to return overdue books. Since, however, we don't want to send reminders to people who've already returned an item before the due date, we need to clear from the file the slips for any items that have already come back. The only way to find the slip in the date file, however, is from the date on the slip that stayed with the book.

Note that under this system the library does not have any easy means of determining what all the items are that a particular patron has, without doing a lot of manual searching through either the call number or dated circulation files. In general, a book library isn't even interested in this, as long as the items are returned.

A very vital function of the circulation operation is to get the item back to its proper place on the shelf. And, for that, it needs some type of call number (shelving address) on the item. For its own protection it also needs to have some indication of ownership on the item itself, generally in the form of a pasted-in bookplate or an ownership stamp. As with other areas of picture librarianship, the circulation function of a library of images is both simpler in some ways and more complex in others than that of a book library, though the same general principles apply.

Two of the major differences center on the number of items involved in each transaction and the financial/legal stakes involved. For a book library, a single user may check out from one to perhaps a dozen items at a time. There may even be a policy limiting the number of items that may be checked out at once. For picture libraries, a single transaction can involve several hundred images, and there's no logical reason to set an upper limit to how many images a client may have at one time—as long as the client wants to see these and there's a possibility of a sale of rights for these images.

And while books loaned by a typical library may average between $10 and $50, the replacement value of a single transparency—because of its future earnings potential—may be $1,500 and up. Also, on a typical submission to a publisher, the only thing that client is given permission to do with the submitted material is simply to look at it.

A major part of the circulation documentation is taken care of by a legal form that accompanies submissions—a form generally called a consignment sheet. It spells out what is being sent, what may be done with it, and when the material is expected to be returned.

LABELING MATERIAL FOR CIRCULATION

Before we get into the specifics of record-keeping for circulating images, however, let's go back to something we've alluded to in past chapters, but not discussed in detail—the information we need to add to the item itself to make sure it gets returned and filed in the correct place. How much information and what kind of information do we need on an item?

It depends on what's done with those items. If your negatives do not leave the premises—i.e., all printing is done in-house—then simple numbering on the sleeve or page which serves as their permanent container, along with a brief identifying phrase (especially if you don't do full cataloging for these items) is sufficient. If they go to an outside lab for printing, the sleeve or other enclosure should certainly contain the owner's name and address, even if it is being sent in an outer envelope which contains this information. If only one negative or strip of negatives is normally out of its permanent enclosure at a time, the negatives generally would not need any additional information on them, since the film already is frame-numbered—and getting any additional information onto the borders of the negative is exceedingly difficult.

Transparencies and prints are another story. Even if sent in some type of larger container, transparencies will be individually handled at some point and may become separated from their container. For instance a single transparency from a consignment may be selected by a publication and held while the remainder are returned.

Every transparency and print should, at a minimum, contain ownership information and (transparencies, especially) information that will allow the item to be re-filed when it is returned. That ownership information can be and usually is combined with a copyright notice which affords the owner protection against undesired or uncompensated uses.

I have several rubber stamps that begin with "© ERNEST H. ROBL" and which include my mailing address. These just fit on the long side of the front of a 35mm transparency mount. On one of the narrow sides, I stamp the file number, on the other narrow side, the date. That still leaves some remaining space on the front of the mount, which can be used in a variety of ways.

I know some people advocate putting descriptive information on the slide mount, in the form of a brief caption. However, it's not only difficult to get enough useful information into that small amount of space, but also extremely tedious to write that on every transparency mount. Yes, you can have stamps made up with the names of cities, states, etc., but that's seldom enough for a client who wants to know something about the specific building depicted. I provide brief general descriptions on the

My standard scheme of labeling vertical and horizontal 35mm slides. They show the accession numbering system used, and they file accordingly in chronological order in my file drawers. The fourth side of the slide front is left available for any special message (such as credit for another photographer). For submissions, captions keyed to the slide numbers are supplied separately.

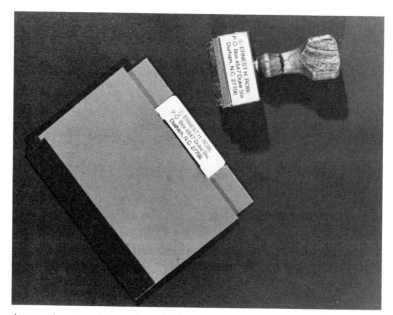

A stamping template or jig, which is cut from two pieces of matte board and then hinged with photographic masking tape. It helps align the stamps used to mark slide mounts, and keeps ink from marring the image area of the slide.

consignment sheet, and, where appropriate, longer captions on additional sheets, keyed to transparency numbers, with each submission.

I mentioned earlier the problems connected with use of a classification scheme for call numbers (or filing addresses) of images. Classification schemes, to be really effective, need a lot of digits to take care of the various levels of the classification hierarchy. Accession numbers, on the other hand, can usually get by with as few as six digits even for very large collections. After all, those six digits would let you file some 999,999 items.

The fewer digits are involved, the easier it is to file and retrieve items. And for six-digit accession numbers, even if you elect to start a new sequence each year and use the year for the first two digits, you can buy a six-band rubber stamp for less than $5—and that's by far the simplest and neatest way to get the numbers onto the slide mounts.

A couple of practical hints about stamping information on slide mounts:

The old fashioned cloth stamp pads work better for stamping information in small type onto slide mounts than foam ink pads.

It's easy to cut a template from mat board or similar material to cover the image of a transparency while leaving the border uncovered to stamp on information. The template not only helps align the stamp and assure that the impression is neater, but also avoids the possibility of getting ink on the image itself.

I've tried a self-advancing metal numbering stamp, which, incidentally, costs many times the price of a simple six-band rubber stamp, and gone back to using the manually advanced rubber stamp. The cheaper stamp was easier to use and generally produced neater-looking and more legible numbers.

What else is useful on a transparency mount in addition to ownership/copyright information and the file number? That depends on the nature of the collection.

I also stamp the date, when known, on one of the narrow sides of the mount. For any transparencies by someone else that come into my possession, I add the name of the photographer.

Though most organizations are well aware that the normal practice is to sell only rights to an image—not the image itself—there are still cases where I feel I need to emphasize this. So, in some cases, I have stamped "Transparency must be returned after use" on items sent in submission.

A frequently overlooked indication on transparency mounts is orientation, which may be necessary for proper use of some images. By orientation,

99

I mean "which way is up" or "which way is north." The first may apply for reproductions of abstract art; the second with aerial photos. In both cases, orientation is easy to indicate on the mount (or border of a print) but often difficult to describe in words on an accompanying caption.

KEEPING TRACK OF CIRCULATING MATERIAL

All right, so, now we have our transparencies numbered and labeled—stamped with the above-mentioned information. They're in our fully cataloged file, and, by using our subject catalog we're now ready to pull images for use, either just pulling together a tray of slides to show, or a submission to an international publication.

In either case, we'll want the same information that book libraries need about their holdings, at least for some of our materials—"Where is it and how long has it been out?"

For 35mm slides, it's easiest to maintain part of our manual circulation file within the slide file itself. For each transparency that's pulled, we insert in its place a slip with its number and indication of its location, either in coded or written-out form. A 2 x 2.25 inch slip that protrudes slightly above the filed slides quickly makes it obvious that a particular item is out. If we use one color for guidecards marking the beginning and ends of groups, a different color is needed for the "item out" markers. This is precisely the system that I used for a couple of years until switching to a data base on my microcomputer for my circulation records.

Even before I went to a computerized file, I started assigning three-digit location codes. Numbers 001 through 025 are for slide trays; numbers above 100 are for clients. The numbers 26 through 99 are for other internal uses. The "item out" marker would simply say "810123–012"—indicating that the slide was in tray 12; or "790123–105"—showing that the item had been submitted to Kalmbach Books.

Keeping track of how long material has been out or what all the material is that a particular client has is a little more difficult, but can be done with carbon copies of consignment sheets. (We're not particularly interested in how long items have been in our own slide trays, since we don't have to send ourselves reminder notes.) One folder holds copies of consignment sheets sent to all clients in chronological order. By checking the folder at regular intervals, we can tell which items have been out too long and should have a reminder sent to the client.

Additional folders are set up for each client. When the material is returned, the consignment sheet copies are pulled from these folders and moved to some permanent file or discarded if there is already another copy in a permanent file. For partial returns, the returned items are simply deleted from the consignment sheet copies, but the copies remain in the respective folders.

Today, a computer data base lets me keep track of all that information, quickly generate printouts of all material out (sorted either by date out or by client), and check for data on an individual item or a particular submission. For items more or less permanently kept as a program in a tray, I can generate a printout of the tray—in slot number order—or quickly locate a particular item by slot number. It's worth noting that a circulation file is one of the easiest library functions to computerize. It's something that can be done even with relatively simple computers—something that cannot be said of all other library operations.

Incidentally, I have submitted both transparencies made by a friend and others made by my father in response to stock requests—where they had images I didn't. The transparency mounts were stamped with my return address, but with the name of the photographer below the image. Since I needed to number these images for captioning purposes—and to keep track of them with my computerized circulation data base file—I simply assigned higher sequence numbers than I use annually.

I've already mentioned that I normally add between one and two thousand transparencies to my file in a typical year (though I often shoot a much higher number). Using my accession numbering system, this meant that in 1986 my slide numbers would run from 860001 to perhaps 862000. For any of my father's transparencies that I send out (along with a photocopy of a signed agreement showing that I'm authorized to market his photos), I begin the numbering with yy7001, where "yy" are the digits for the year. My friend's material is numbered in the yy9001 sequence.

A similar scheme can be used by any group of photographers who jointly market material, regardless of whether they normally keep all the images at a central location or retain individual possession of the material. Such a numbering scheme also allows catalog records from all of these photographers to be combined into one catalog, or what libraries call a "union catalog"—one representing several collections.

In the latter case, an agent representing all of the photographers could maintain a union catalog of their holdings while each photographer could also have an individual catalog of his work. Both in a temporary or semipermanent central file, the work of individual photographers would be kept in separate blocks, allowing this material to be easily returned to the photographers later. Even in the union shelflist, the work of individual photographers would be kept in separate blocks by this numbering scheme.

Access for all images of the same subject—regardless of photographer or location where the image is held—would be together at the same location in the catalog. The concept of a union catalog for several collections is relatively easy to carry out both for a manual (card) catalog and one in computer form—though there do have to be some agreements on standards in order to merge computer files.

This concept can also be used for a catalog representing different formats. For instance, a photographer with files of both 35mm and 6 x 6 cm transparencies could number one format in one sequence, the other in another. Another option would be to use some type of prefix in front of the numbers for these situations. A combination of both the prefix and additional numbering sequences could be used for several photographers working in a number of formats.

In a computer file (either a circulation file or catalog) logical operators—specifying "and," "or" and "not" and "wild card" characters in a query could then easily narrow the search to items in a particular format by a particular photographer. (My data base program allows searches to be input in the form "==7==="—which would bring up any record with a "7" in the third position of the item number.)

PERSONAL COMPUTER APPLICATIONS

COMPUTER VS.

CARD CATALOGS

Why the Computer May Not Solve All Your Problems

Knowing that I am an enthusiastic advocate of computers, nothing surprises people more than the fact that my transparency catalog is in card form.

I own two microcomputers, two printers, and enough peripherals and accessories to start a small computer store. Most of the work for this book was done on my desk-top computer. I've written everything from correspondence to magazine articles at locations ranging from hotel rooms to airplane seats to mountain overlooks miles from any electricity on my lap-top portable computer, and hardly ever go anywhere without it.

I own and use programs ranging from accounting to word-processing, and covering a wide range in between; I've written some programs for my own use and extensively modified programs written by others—though I don't consider myself an experienced programmer, by any means. In my work at a large academic library, I've taught dozens of people how to do a variety of tasks that involved the use of computer terminals; I've even taught some short courses providing an introduction to microcomputers. I've worked on manuals for programs produced by professional programmers and written articles on data communication for a small computer magazine.

Yet, my catalog is currently maintained in card form in a six-drawer cabinet. To understand the why is also to understand both the capabilities

of computers and their limitations—and that all computers are not created equal. But I would never try to talk you out of getting a computer—any computer—and I would now find it extremely difficult to run my photo business without mine.

I consider my desk-top computer the second employee in what is essentially a one-person business. (I do pay for help—for anything from proof-reading to re-filing slides—when I need it, but I have no full-time or even part-time permanent staff—other than my computers.) And, as much as I like human company, it would be difficult to find a helper always willing to work whenever I am—even if it's at 2 a.m.—or, someone who can do a terribly boring repetitive job over and over again thousands of times, each time exactly the same, without a single mistake or a single complaint.

Many of you reading this may already own or at least have access to a computer of some kind; others of you may already be seriously contemplating a purchase and may have wondered why I've wasted so much of your time talking about catalog card formats and similar subjects when now you can "just do it on a computer." Well, sometimes you can, and sometimes you can't. And, even if you can, most of the basic principles that apply to a manual catalog—the things I've talked about in the preceding chapters—still apply in an automated environment. Even the most sophisticated computer data base systems will not be able to find your listings for images of automobiles, if what you request are images of "cars"—that is, unless the computer has been programmed with a built-in authority structure, which makes the link from one term to the other.

The ongoing trend in libraries is to go from card catalogs to on-line systems. And the trend reaches from the giant Library of Congress all the way down to the Podunk Public Library. While in the beginning many libraries fooled themselves (or were fooled by others) into thinking that computer catalogs were cheaper than manual card-based ones, the libraries that are at the forefront of automation today are investing in technology for other than purely financial reasons.

A bibliographic catalog (and here I use the term "bibliographic" to include the catalogs of picture collections that we've been discussing in previous chapters—as opposed to mail-order catalogs) is a very sophisticated tool. To do everything that is possible in manual form on a computer, you need a very sophisticated computer and a very sophisticated program, or even group of programs, if you're going to use it to manage your entire library, and not just use it as a catalog.

To be able to do on a computer what I currently do in my card catalog, I would need a computer costing about ten times as much as the one I'm currently using. Of course, both the good news and bad news, depending on how you look at it, is that in the approximately five years since

I bought my first computer, the marketplace has changed to the point that you can now buy a computer with more capabilities for less than half of what I paid for mine.

I'm not trying to talk you out of considering going with a computer-based catalog. Far from it. For some of you it may indeed be the best solution. I just want you to go into automation with your eyes wide open.

One of the great lies, ranking right up there with "Trust me," and "The check is in the mail," is "Computers make things simple." However, don't check out of this chapter just yet even if you don't think you can afford a sophisticated computer. There are a great many areas connected with the management of a picture collection other than having an on-line catalog where a computer can be of enormous value. For many of those applications, even a relatively primitive computer will do just as well. I'll get to those, too. You really don't have to go for broke to benefit from what a computer has to offer.

Let's go back to the question of the on-line catalog, and why libraries are going to computer-based catalogs if they aren't necessarily cheaper—factors you need to know about if you're considering a computer-based catalog, either by itself or as part of an integrated library package.

Although computers don't necessarily let you do things better or cheaper, sometimes they let you do things differently and often that's more of an incentive. A major example of that is the way the computer allows you to post-coordinate searches instead of having to pre-coordinate subject headings.

Remember from our discussion of subject headings that if we want to bring out a geographic aspect of a topic or a topical aspect of a geographic subject, we need to combine both into one subject heading to be able to find the relevant record in a single search. With computers, you need only to have both the topic and the geographic aspects in separate access points; then, in the search, if both aspects (or even more than two aspects) are specified, the computer can locate all records where all the relevant access points apply. Searches can be constructed using the logical operators "and," "or" and "not"—even allowing you to exclude from your search items in which you are not interested.

Another beneficial aspect of having the catalog on a computer is that you can provide features for giving users instructions in using the catalog—right on the computer terminal.

There are financial incentives for computerizing, too, but unfortunately many of those do not apply to picture collections. Many of the financial incentives for book libraries come from sharing of resources—membership in the so-called bibliographic networks. At a library conference in mid-1985, one vendor was demonstrating an impressive library package running on high-end IBM microcomputers—PC XTs and ATs—and the going rate

was $15,000, which puts it somewhat outside the range of even many small businesses.

There's at least one other important factor to consider for any library function that you put on a computer: Computers are machines, and machines can break down. What do you do when the computer isn't working? The amount of money you can commit to computerizing has to allow not only for the primary system and software, but also for backups to that system. Unless you can afford an expensive on-site service contract, in some cases running as much as 30 to 50 per cent of the cost of the equipment—on an annual basis—you probably won't get same-day fixes for problems. Though my computer has given good and faithful service it was in the shop for a couple of weeks last year getting a keyboard transplant. After millions and millions of words, the original keyboard had just given out.

Yet during that time, I still had access to my catalog and I was still able to type up consignment sheets on my electric typewriter. Though my circulation file is on a computerized data base, I had printouts of key information and it was possible to update the files once the computer came back. Correspondence was done on my smaller portable computer, using the same printer that I normally use, and people receiving the letters never noticed any difference.

Had the catalog been on my computer, I would have had some far more serious problems. Businesses that are dependent on computers for their day-to-day operations either have to have service contracts that guarantee repair or replacement of critical equipment within a reasonable amount of time, or they have to have enough redundancy of equipment so that failure of any one component won't cripple the operation.

Also, the more sophisticated computers get, the more time you spend managing the computer and its files. Hard disks can hold millions of characters of information, but they too can fail, and unless you have a foolproof means of backing up and re-creating the data you've stored on that disk, thousands of hours of work that went into creating that data can go down the drain with a disk failure. And backing up a five or ten megabyte hard disk either onto tape or floppy disks can be anything but fun. As you will see in a minute, a relatively simple transaction such as adding a new cataloging record to a data base can affect a number of computer files in a cataloging system—which consequently may need to be sorted and then backed up.

Though many of the readers of this book will have had at least some exposure to the basics of computing, it may be helpful to review some of the reasons why some library applications require far more sophisticated equipment than what you might use for simple word processing or shooting down space invaders. Automation of libraries is a still developing and

quite complex field, and, unless you've already had extensive exposure to computers, you would do well to first tackle some introductory materials on computing in general and then on library automation in particular before taking the plunge.

Okay. A computer, regardless of size and capabilities, consists of some basic components: the central processing unit (or CPU), the heart of the computer, which does all the actual work; input and output devices with which the computer interacts with the real world (these include, but are not limited to keyboards, video display screens, and printers); and two main types of storage—Random Access Memory (or RAM), where the computer keeps the data it is currently working with, and mass storage, generally a magnetic means of storing information (disks, tapes, etc.) that will preserve that information even when the power to the computer is off (whether intentionally or by accident).

There's also another kind of computer memory called Read Only Memory (or ROM), but though that's found in most computers and fulfills some important functions, particularly in starting up the computer when power is first turned on, it's only peripheral to the points we're discussing here. ROM is essentially a "hard-wired" set of instructions or data that cannot be changed, but which is not affected by having the power turned on and off.

RAM, on the other hand, is "volatile" in the sense that all the information in that part of the computer is lost when the power goes off—though, of course, there are means of protecting against that happening accidentally. The important thing to know is that for the computer to be able to do anything with information, it first has to be in RAM. So for the CPU to process that information—whether to change it, sort it, or find a particular word or element, or to perform some mathematical operations—the information has to somehow get into RAM.

This can happen either through some input device (like typing it on a keyboard) or "reading" it in from mass storage, such as from a floppy disk or hard disk. What I'm getting to are the reasons why most library applications require three major elements—large mass storage (with rapid access); a large amount of RAM; and a fast CPU. That, in turn, has a lot to do with how computer data bases work. A data base is simply arranged in some structured way—with structured being the key word.

AN INTRODUCTION
TO DATA BASES

The Key Word Is Structured

There are basically two different types of data-base formats: fixed-length record/field and delimited.

FIXED LENGTH RECORD/FIELDS

The fixed length record/field format is by far the most common for smaller computers and can be thought of essentially as a table format. To understand how computers deal with a fixed length data base, let's look at an example that has nothing to do with libraries—a list of people's names and phone numbers:

```
Smedley, Jonathan              919-123-4567
Smith, Sally                   123-999-7878
Doe, John                      555-234-5869
    . . . . etc.
```

In this particular case we have a data base with records (each line in the above symbolic table representation) consisting of two fields: one of 30 characters for the name; the other of 12 characters for the telephone number. Again, the whole list or file is a data base. The lines are records; the units within the lines are fields.

Typically, the computer would store the information (on disk, in RAM,

etc.) without any markers between the fields and records—just as one long string of characters. It's easy enough, however, to have the computer display or print the records in table format, even adding column markers, by simply storing somewhere the fact that 42 characters make up a record and that the fields are 30 and 12 characters each. So, after 30 characters, the computer adds a column marker; after every 42, it knows to begin a new line. We can also have the computer tell us very quickly how many names (lines) we have in our list. It simply counts the total number of characters in the file and then divides by 42.

Now, all of this had to be decided on by the person setting up the data base. Within certain limits, depending on the data base program being used, there is a choice of the overall length of the record, the number of fields, and the length of each field. Once these factors are set, however, you can't change them. In the above example, a name of more than 30 characters won't fit into our "table"—nor is there any provision for extensions to the phone numbers where these would apply.

We could, of course, either have added a third field for an extension to begin with, or have allocated a larger field for the phone numbers. In either case, if most of our phone numbers don't have extensions, we'll be storing a lot of empty spaces. That's one of the major disadvantages of the fixed-length format: Once you allocate the length of a record or a field, you have to store that much data—whether it contains useful information or just blank spaces. You can see that in our name field, since we made allowance for names of up to 30 characters total, we're already storing a lot of blank spaces with the shorter names.

In this particular case, even if our list contained a thousand names, there probably would be no problem in storing the entire 42,000 characters on a disk or even having it all in RAM at the same time—even on a very small computer. With more complex data bases, with dozens of fields and hundreds of characters per record, the situation gets more difficult, though there are ways of getting around this, too.

First, let's take a look at why we need to have records and fields to begin with. Partly, it is because the computer needs to manipulate the information—such as to display or print it out in table format. Another example would be in searching for a particular record in a large file. And, here we get closer to some of the library applications of data bases.

Computers can search for information a number of different ways, but for our example we'll say that there are two basic ways—by field and freetext. Freetext will work with any type of file, but can be very slow for large files. Let's say that in our telephone number list we want to find someone whose last name is "Smith." With freetext searching, the computer starts out at the beginning of the file and compares our "search string," which in this case happens to be five characters long, against

the first five characters in the file. Failing to find a match, it now moves over one character in the file and compares the search string against characters 2–6; failing to find a match, it then compares against characters 3–7, and so on. Just to get to the name Smith in the third record, the computer has to make nearly a hundred comparisons.

On the other hand, if we know that the last name will always come at the beginning of the first field of each record, we need to perform only three tests to find the match: Once for the first record, then jumping forward 42 characters for the second record, then jumping forward another 42 for the third, at which point we find a match.

Perhaps you've heard that even the simplest microcomputers can perform some two million operations per second, with large mainframes now doing perhaps 25 million steps per second, so it may not look like there's that much difference and the wait would not be that long even for a freetext search of a long file. Well, you have to understand that each of the comparison steps that I mentioned in the previous paragraphs may actually mean dozens of steps for the computer's CPU, because moving information in and out of the CPU, keeping track of where it is in reading a file, jumping forward a given number of characters in RAM are all individual steps. With very large files, search times do become a problem.

Another problem with freetext searching is that it can give you unanticipated results. Let's say you want a list of all people with the area code 123. A field by field search would quickly get you to the second record. A freetext search would also bring up the 123 buried in the first phone number—which is really not what you want at all.

And remember that a computer can work only with information in RAM. For information on a disk or other mass storage medium to get to the CPU, it first has to be read into RAM. Disk access, even for the relatively fast hard disks, is much much slower than working with information already in RAM.

How do we get around this with a very large data base so that we don't have to read one record (or even a group of records) at a time from a disk to find the information we need? We use indexes.

Let's look at another example, building on the telephone number list we had before. Only this time, in addition to names and telephone numbers, each record contains many other fields, including street address, city, state, zip code, occupation, etc. Let's say each record contains a total of 256 characters:

```
Smedley, Jonathan      919-123-4567 125 Elm
Smith, Sally           123-999-7878 311 Sout
Doe, John              555-234-5869 1515 Bro
     . . . . etc.
```

You'll just have to imagine the rest of the "table" out to the right, since there's no easy way to illustrate one 256 characters wide. We probably wouldn't display it on the computer in table form, either, but rather have each record as one screen, possibly with some type of label for each field added when the record is displayed.

Let's also say that we have a thousand names (records or lines) in our data base, which now totals 256,000 characters. Even on a microcomputer with 256K (or approximately 256,000 characters) of RAM, the whole file will now no longer fit into memory, since we will normally need at least several thousand characters of RAM for the program instructions.

We can however, create a subset of the data base that will fit into memory and minimize reading things in from a disk. Let's say that we would most likely be looking up records by people's names. (And highly unlikely to be looking them up by their street number!) We now clone a sub-data base that contains only two fields, the name and the record number of the full record:

Smedley, Jonathan	0001
Smith, Sally	0002
Doe, John	0003
. . . . etc.	

If we're looking for the complete data on John Doe and enter the search string "Doe," and the computer searches field by field in the index file, it will quickly discover that Doe is our third record, then go to the disk file for the full data base and read in only the 256 characters starting at 513 characters into the file (skipping the first two records) and display that full record. (The field lengths, labels for display, etc. would normally reside in another file which is read in when the data base is first loaded, and which the computer uses to make the necessary calculations.)

For very large files we can improve the searching even more by alphabetically sorting our index, so that it now looks like this:

Aardvark, Bobbie D.	0948
Benson, George	0508
Carpenter, Sam G.	0211
Doe, John	0003
. . . . etc.	

What we do now (actually what a programmer does for us when setting up the data base program) is use a technique called "hashing" in searching. Rather than searching record by record through the index, the computer looks half way through the index to see if it has already gone too far to

find the record that we want to find. If it has, then it knows that the name is in the first half of the index, and now divides that in half, performing the same test, over and over again for successively smaller parts of the file until it either locates the record we want or determines that it doesn't exist in the index file. On the other hand, if it determines that it hasn't gone too far by jumping half way into the index file, then it knows the record can only be in the second half of the file, and begins narrowing down its search there.

DELIMITED FORMATS

Up to now, we've been talking only about fixed format records. The other type, delimited, allows our records and fields to be of variable lengths, depending on the nature of the information they contain. Delimited formats have other problems. As the name implies, the records have to include limit markers that define the boundaries between fields and records. Depending on how the data base is set up, fields, as they are stored, may also require labels (at least in coded form) telling you what each field contains. This latter subset of delimited data bases allows you to leave out empty fields from records, thereby saving some storage space.

A delimited version of our first example—a data base containing only names and telephone numbers—might look like this:

```
Smedley, Jonathan[FS]1919-123-4567[RS]
Smith, Sally[FS]123-999-7878[RS]
Doe, John[FS]555-234-5869[RS]
. . . . etc.
```

[FS] and [RS] stand respectively for the single character codes that represent a "field separator" marker and a "record separator" marker.

The main problem with a delimited file is that while we can avoid storing blank spaces, we now need to do a whole lot more record keeping as to where individual records and the various fields within them begin. Remember, we can't just jump ahead two times 256 characters to get to the third record. There is also the problem of having to update all that information, if you insert or delete a couple of characters in a name to correct a typographical error.

It would be very difficult to fit the types of cataloging records we've been discussing in previous chapters neatly into any kind of fixed or table-type format. One record may have a brief description; on another you may want much more space for the description. On one record you may have only one or two access points. On another you may need seven or eight. And while it is possible on even relatively simple data-base programs to group fields together for searching or generating indexes—say, defining

five fields in a record as subject access points and generating one index from them—without it really mattering to you in which of the five a particular subject heading is stored, there is no way to allocate more access points, once you have limited yourself to five.

So, the really sophisticated library computer packages use delimited or variable-length record formats, along with multiple indexes, and all the attendant record-keeping. With a well-written program, most of that activity will be "transparent" or invisible to the user. That doesn't mean, however, that the person inputting data is not going to have to do a great deal of coding so that the computer can manage that data. There is an international standard for coding cataloging data, called the MARC format (for MAchine Readable Cataloging). Its manuals run into hundreds of pages, and any kind of detailed discussion of this format is far beyond the scope of an introductory book like this.

Oh, yes, in case you were wondering how a computer deals with searches using logical operators ("and," "or" and "not") or post-coordinated searches—for index-based searches of a large database, the computer simply compiles temporary lists of the record numbers of records that match each of the individual search elements, then compares those lists with each other, displaying or printing only those records which match all the criteria specified.

A final point, before getting on to much better news about computer applications: computers can deal with information much better in a coded or compressed format than with material in spelled out form. For instance, when looking for material on North Carolina, it is much easier for the computer to compare the search key "NC" against a file containing such abbreviations as "MI," "NC" and "SC" than it is to process a file containing fully spelled out data. Of course, spelled out information is easier for most humans to deal with, so, in some cases you have to store information both ways, or have some method of converting back and forth between the coded and spelled out formats.

I mention this only as a means of pointing out that as part of the MARC standard, there exists a whole system for formulating geographic codes (as well as compressed codes for other things). So, even if you decide to set up a catalog data base that doesn't use the full MARC format, I still advise you to talk to someone familiar with that system about borrowing parts of the standard. Why re-invent the wheel when someone else has already designed a system for dealing with most coding problems?

Of course it's not just processing the data in compressed format that's helpful; it also takes up a lot less space on your diskettes that way—if it's possible to do it that way. And that brings up a major word of caution about some of the software packages that purport to let you "catalog" slides or negatives.

SOFTWARE PACKAGES

I've seen advertisements and descriptions of programs that go something like this: The program allows you to design a list of say a maximum 250 descriptive phrases (sometimes described as "keywords" though they really aren't in the sense that that term is normally used) of up to 64 characters each. Then on each computer record you can assign up to a given number of these subject classifications (that's what they really are), which are then searchable, either singly or in combination.

What these systems do is create two linked databases—one is a table of the list of classifications and a one-character code assigned to each. The other contains the records on which the subject classifications are stored as single character codes. That's how the records and overall data base fit on a small computer because the fully spelled out subject categories need to be stored only once.

This type of system may work for some collections, but consider this: if your collection contains either photographs of specific people or of specific places, and you need access by the names of those people and/or places you are very quickly going to run out of the list of 250 possible subject categories. And, once you do that, there's no way to expand the number of available categories. But, as I promised, there's better news ahead.

COMPUTERS AND
YOUR COLLECTION

Despite the Bad News,
Many Possibilities Remain

Computerization is not a goal in itself, though many people confuse it with one. It's a means to an end. Begin by asking what it is that you want to accomplish, including what type of access you need and how fast you need it. Then, and only then, should you be looking at how you can do that—and at how a computer can help you do that.

Some of you may be able to go for a computer system and software with all the bells and whistles that anyone could want. If so, more power to you. Quite possibly one day—if computer and software costs continue to come down and I find a package with just the right features—I'll pitch my card catalog in favor of one on a computer that can do more than the cards. Of course, I want a system with an infinately variable record length and an unlimited number of fields—with complete authority control. If I can find such a system at a price that I can afford, I can use my existing shelflist to input the records into that data base. In the library business, that process of going from a manual to an on-line system is called "retrospective conversion."

Until then, I'll be perfectly happy with my card catalog, where I already have an infinately variable record length and an infinately variable number of fields. At the same time, though, I'll continue to wear out the keyboards on my computers, because there are still dozens of uses for them in my photo business, not counting the writing of articles and books.

CIRCULATION

Want to know where one of my transparencies is at the moment, if it's not in the file? It's just a matter of stuffing the right disks in the computer. Periodically, I run a printout of all material that's been out of my files— sorted by the length of time it's been out. For items that have been out "too long," I send out a polite reminder letter—along with a page exactly describing the material that was submitted. The basic text of the letter is on a computer disk; the list that gets enclosed is a printout from my circulation data base.

Although a sophisticated catalog is difficult at best to force into the molds that computers provide us, a circulation system fits very easily into even the simplest data base system. All you need are records that contain an item identification, a location code, and a date field for the last change in status. An additional field with a transaction number is also useful for quickly bringing up all items on a particular submission. With these four fields, records could actually be less than 32 characters in length, permitting thousands of items in file on even a small computer with limited memory.

I went a little further, and added a brief identifying phrase for the content of each transparency, as well as fields that let me produce a tray listing (by slot number) for items permanently kept in a slide tray as a slide program and that indicate whether or not a transparency should be returned to any location other than its file space.

Since only a small portion of any photographic collection normally circulates, and only those items actually circulating need to be entered in a circulation data base, a small computer can easily accomodate the circulation records of a picture file of tens of thousands of items.

WORD PROCESSING CAPTIONS, CORRESPONDENCE, AND CATALOG CARDS

I've already mentioned word processing. Supplying stock photos to publishers and other potential markets involves a surprising amount of correspondence. The pictures you send out need captions, and in many cases, there's increased potential for use of your pictures if you can supply longer text pieces, all the way up to full-length features.

Once you've tried writing on a word processor that produces a perfectly typed page each time no matter how bad your typing, re-arranges sentences and paragraphs after you've written them, and does dozens of other things for you that your typewriter never did, you'll never want to go back to writing any other way.

Initially I considered organizing complete captions into a data base of their own, but found that since many images can be used to illustrate a variety of different things, it's often necessary to write different captions

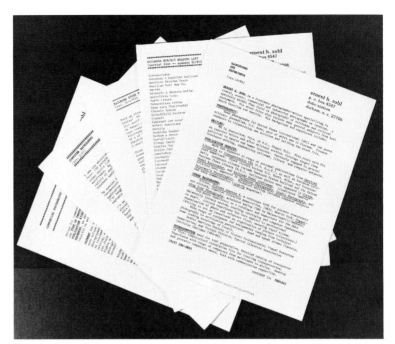

Computer-produced resumes, stock lists, business forms and policy sheets are easy to update and produce in either small or large quantities. It is easy to change information to emphasize the particular interests of a specific client.

for the same images. Since, however, all captions from previous submissions are stored on disks, where submissions are substantially similar, it's often possible to re-use most or all of the previous captions. I simply copy the text from one caption document to a new file and then make any necessary changes or additions to that, before saving that, too, on a disk.

Correspondence and captions aren't the only things that can be done on a word-processing program. Your images will be used only if people know about you, and that requires making contact with potential clients, by sending promotional material through the mail. My promotional mailings include printed sheets with sample images and sheets with a resume of my publication credits, other qualifications for providing services, and descriptions of the major subject areas in my collection.

Both the resume and the major subject sheets have undergone dozens of revisions. If I know a potential market is looking for a particular type of material that I either have or know that I can do, that gets some additional emphasis. Of course, where I've added some major new material to one of my subject specialties, particularly where I've filled what I considered to be a gap in my collection, that too gets added. To keep things simple each of the descriptive sheets is edited to one page. When new things get added, other things usually are deleted.

I produce the cards for my catalog using my computer and a letter-quality printer. The computer overtypes the subject headings on their respective cards. While there are a number of programs designed specifically for producing catalog cards available from various vendors, almost any good word-processing system can be used for this purpose. In fact, I looked at descriptions of many of these programs before deciding that I already owned a program that offered many more features than any of these.

The program I use is "SuperScripsit" on a Radio Shack Model III—but virtually any word-processing program with the capability of producing form letters using a list of addresses can serve this purpose. Most word-processing programs enable you to send letters with identical text to a number of people, and still have them individually addressed. Depending on the nature of the correspondence, the recipient may not be aware that dozens of others are receiving identical letters. You create a master document—the basic letter—which, rather than containing specific information for the various parts of the address, salutation, etc., contains only so-called "merge codes." Another document called a "variable list" is then created—either from an existing data base, or specially for this purpose. When the letters are typed, the computer matches the merge codes with the appropriate variables from the list, and inserts the appropriate text in the correct places.

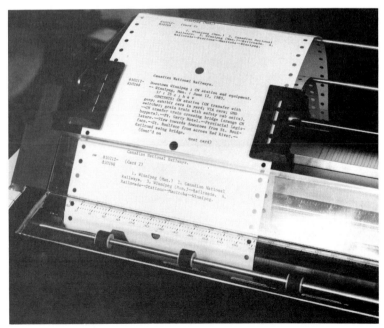

Continuous cardstock with detachable sprocket strips (available from most library supply houses) lets you produce overtyped catalog cards on computer printers that have adjustable tractors. Not all printers, however, can handle this type of stock.

Catalog-card production works the same way: I create the basic record with a merge code at the top where the overtyped headings go. Then the tracings are "block copied" into a variable document, and, with a little bit of manipulation, are made into a variable list formatted correctly for the program's use. Later, the computer thinks it's typing little 3 x 5 inch form letters with different one-line addresses at the top.

Why is doing this with a word-processing program better than using a specifically written card-print program? A sophisticated word-processing program has far better editing features, for inserting, deleting and moving text around. Most word-processing programs also have the capability of creating "user macros." These are stored actions that normally require you to press a dozen or more keys, and then let that action be called up by using a single keystroke. If I'm cataloging groups of items where the same phrase comes up over and over, I can avoid having to type it each time by storing it just once. Most of the work of converting the tracings at the bottom of the record into a correctly formatted variable list has been stored with user macros. Also, the word-processing program puts no limits on the lengths of various elements, unlike card-print programs.

Using sprocket-fed continuous catalog cards available from most library supply vendors can vastly speed up the production of cards. But be aware that not all computer printers can handle such heavy stock without jamming. If producing catalog cards is an important capability, get samples of continuous card stock and try them out before purchasing the printer you plan to use for that purpose. In general, bottom-feed printers (where the card stock does not have to go around a small-diameter platten) will work better for this purpose.

COMPUTER BULLETIN BOARDS AND ELECTRONIC MAIL

Using computers to communicate with clients and potential clients, is an application still in its infancy and shows great potential. Here, the information being communicated is quite different from what is exchanged on the bibliographic networks used by book libraries. The value of picture-oriented computer utilities such as Photonet can best be illustrated by the following true story:

Not long ago, I sent a selection of sample pages to a picture editor at a publishing house that was considering doing a North Carolina textbook. She noted a shot of the interior of the Cape Hatteras Lighthouse included with that selection, and said, "Six months ago, I would have killed for a picture of a spiral staircase like that. It was exactly what I needed—but couldn't find."

Well, I have only a couple of pictures of that one spiral staircase—hardly something worth noting on a stock-subject list—but for that publisher, one would have been enough, and I would have made a sale.

Services like Photonet allow picture users to post their needs—particularly for unusual subjects without a single obvious source—on a computer bulletin board. These postings are seen by a variety of suppliers, who may not otherwise be able to get the word out that they have that particular image. If a picture supplier sees a request that he may be able to fill, he then responds by telephone or electronic mail to see if his images really do fit the requestor's specifications.

For a photographer out on the road, an electronic-mail service also helps to keep in touch with clients and potential clients. There's much less chance for ambiguity and misunderstanding in a written message left on an electronic-mail system than in a spoken one on an answering machine. And unlike a normal mailbox that fills up with junk mail while you're away from the home base, your electronic mailbox is accessible from anywhere in the world where there's access to a telephone. Photonet, for instance, can be accessed through local telephone numbers from virtually any city in the U.S. and most major cities around the world. And, unlike messages entrusted to normal mails, an electronic-mail message is available to the recipient—as soon as he logs onto the host system.

The photo-request bulletin board and private electronic-mail service among subscribers are only two of the services offered by Photonet. Other modules of the system allow agencies to provide private messages to their contract photographers, allow photographers to order equipment from participating vendors, and allow subscribers to tap into other data bases containing airline schedules and news stories as needed.

Of course, these services cost money, but they do give picture suppliers away from the major cities access to otherwise distant markets. At the time of writing, Photonet's minimum monthly charge is $24 for an hour of connect time; some services on Photonet have surcharges on top of the basic connect time charge. I've usually managed to stay under one hour connect time per month, though I check in at least once a day Monday through Friday. Checking the picture request bulletin board normally takes just under three minutes. Although it's too early to say that being on Photonet has brought me a lot of business, it has led to some useful contacts.

Initially most of Photonet's subscribers were photographers and other picture suppliers. By early 1985, however, a number of major magazines were showing up among those requesting material on the system. This system will continue to survive as long as there is a balance between suppliers and consumers, and both learn how to make the best use of the system.

The future may well see the availability of systems that allow transmission of images from computer to computer—at a cost even the average photographer can afford. These images would not necessarily have to be

This portable microcomputer with a full-sized keyboard fits easily inside a briefcase or photo-equipment case, which allows the traveling photographer to write, take notes, make calculations, and communicate with national databases and clients.

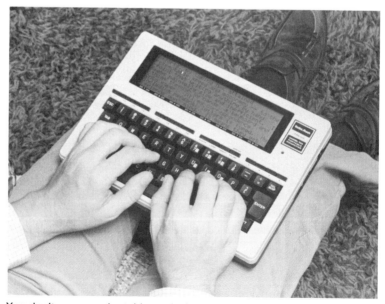

You don't even need a table or desk to use a notebook computer—just a place to balance it on your knees, so you can work in motel rooms, airports, or even in flight.

of reproduction quality. Getting some idea of the content of an image often helps an editor decide whether or not to request the original. For these systems to succeed, however, standards for image transmission and storage still need to be worked out, but work in these areas has begun.

For now, however, Photonet is a step in the right direction. For further information on this organization, which currently does not have any direct competition, write to:

> Photonet Computer Corp.
> 250 W. 57th St.
> New York, NY 10019

The trend in libraries of all kinds is definitely toward automating as many functions as possible, and that generally means using computers. They let us manage volumes of information and do things difficult to imagine a few years ago. Even large libraries have, however, found that it's not always just a simple matter of "putting it on a computer." Both of the two largest North American library organizations, the American Library Association and the Special Libraries Association, have special sub-units devoted to discussion and exploration of the issues of technology.

The last three chapters have only scratched the surface of one of the most complex areas of librarianship. Here, more than anywhere else, it's worth doing further reading and getting some expert advice before investing money—often a considerable amount of money which may not have an immediate payback. And don't just listen to one person. Get a second opinion—even about what you've read here.

STRATEGIES FOR GROWTH

GETTING STARTED

How to Tackle the Overwhelming by Asking the Right Questions

Chances are that if you're reading this book you already have a sizable photo collection—one that's continuing to grow, and whose present system of organization isn't working, or at least isn't working as well as it could be. If that's the case, then it's also likely that you can't simply stop doing everything for the next few months just to reorganize your collection.

You've already seen that any system that provides sophisticated access to images has its costs—mostly in terms of the time needed for the cataloging, regardless of whether that information will be reproduced on cards or displayed on a computer screen linked to a data base. Before you decide that the task is hopeless, take a moment to consider the old Chinese proverb about the journey of a thousand miles beginning with a single step. Libraries—or even just their catalogs—aren't created in one fell swoop. They grow a few items at a time.

So, where to begin? Probably not at the beginning of your collection, but rather at the present, where new items are being added now. You know more about your most recent material and can find recent images most easily, but these images won't always be new. I began my first attempts at serious cataloging of my color transparencies at the beginning of 1977, when I already had several thousand transparencies. Nearly a decade later, I still have several hundred uncataloged transparencies from prior to that

time. This hasn't been a problem since these images are now sorted into about half a dozen groups, any of which I can number and catalog relatively quickly should I need that material for a submission.

My catalog began with slide number 770001, which doesn't mean that that's the earliest item represented in it. However, I went from that point forward, concentrating on organizing the new material, and then went back to earlier material once I was caught up with current material or once there was a pressing reason for doing so.

In fact, the decision to begin my accession numbering system with the year was based in part on the desire to keep all material in sequential order—and to add cataloged material both at the end of the file and at the beginning. I've mentioned before that because of other projects that I work on, including ones that consist solely of writing or editing, material gets added to my slide file in spurts. I may shoot a dozen rolls of film within several hours—then virtually nothing for a couple of weeks.

Though I now shoot many images simply to balance out the subject coverage in my file, before I started working at seriously marketing stock photography, the bulk of the material added to my collection resulted from trips—voluntary or involuntary. The latter, of course, includes the time I spent in the U.S. Army. One of the first things I did in attempting to organize the pre-1977 material was to make outlines of the major trips or other events I had photographed in previous years.

The bulk of my slides from 1975 were from a trip to Europe in May. In March, there had been a couple of picture-taking trips up to Virginia to photograph the (now abandoned) scenic Abingdon branch of the Norfolk and Western railway. Later in the year several other shorter trips added photos of other railroads. In 1976 there was another brief trip to Europe, as well as trips to the North Carolina coast and short trips, mostly to photograph railroads.

My first priority was to list the events that had produced slides in chronological order within each year, and then to make some estimates of the total number of slides from each. The fact that Kodak-processed slides have always had the month of processing stamped on them helped.

1975
Abingdon branch
Europe
Durham & Southern RR
SCL trip

1976
Europe
American Freedom Train
N.C. Outer Banks

Of course, these weren't the only events which had produced pictures, but they had produced the bulk.

Based on the estimates of the total number of slides from each event—and making an allowance for both the possibility of the estimate being low and for other material photographed between these events—I then assigned arbitrary starting numbers for these groups:

> 1975
> 750001 (Misc.)
> 750501 Abingdon branch
> 751001 Europe
> 752001 Durham & Southern RR
> 753001 SCL trip
>
> 1976
> 760001 (Misc.)
> 761001 Europe
> 762001 American Freedom Train
> 763001 N.C. Outer Banks

Similar outlines were made for other years, going all the way back to my high-school days when I shot my first slides. This was just the first step of the organizing process.

Many of these major groups would require subdivision for cataloging. It was now possible, however, to begin numbering and cataloging any one group as necessary. My priorities were my subject specialties most likely to be requested—railroads, Europe, and North Carolina. But they already accounted for the bulk of my material.

In the end, it was mostly a random effort, though I usually tried to catalog similar subjects from different years, such as the 1975 and 1976 Europe trips, close together, because photos from both trips often depicted the same towns and I had already grouped together all necessary reference materials such as maps.

This method leaves some gaps in the numbering sequences, but there's no compelling reason for avoiding those. On cataloging records, the arbitrarily assigned numbers starting the major numbering blocks are preceded by an asterisk (*), just to show that there won't necessarily be any items with preceding numbers.

My first catalog cards went into a file box—the kind that you can buy from any office supply store. From the beginning I used cards of the metric dimension used by most libraries—cards that were already drilled with the rod hole—with plans for ultimately going to a regular catalog cabinet.

It was only after I had close to ten inches of cards—about a thousand cards—that I bought that cabinet. I deliberately chose a six-drawer cabinet for plenty of growth space, even though I didn't need all that space immedi-

ately. My current arrangement allocates four drawers for subject cards (A–E, F–N, O–R, and S–Z), one drawer for the shelflist and "author" cards for photos made by others, and the final drawer for supplies, including blank cards.

You'll notice that the above division of the alphabet isn't even. Chances are the same divisions may not work for your collection. Having ten inches of subject cards before making the division let me measure those cards—determine where in the alphabet the quarter divisions would fall. This early measurement turned out to be an accurate predictor of growth, since all four drawers have grown at approximately the same rate.

Each 15-inch deep drawer is now about two thirds full, and, at some point, I'll have to expand to additional drawers. At that point, I'll again measure the total length of the subject cards and divide by the number of available drawers to get an even division.

The most important thing to emphasize about starting is that, short of correcting major mistakes (catalog records actually containing incorrect information) you're never really going to be able to go back and re-do things. Do it the best you can the first time around, making allowances for what you'll need in the future. That means using such things as standard format catalog cards with the rod hole. But do a little experimenting first. Save some of the badly-exposed (or even totally blank) slides that you might otherwise throw out. They're good for experimenting with various formats for stamping or writing information on the slide mount.

Before starting, it's important to stop and think about just why you want to organize your collection. "So that it's organized," isn't a good enough answer.

How will the material in the collection be used—as best as you can predict? Who will be using it, both in the immediate hands-on sense and in terms of end-users (publications, agencies, etc.)? How will the collection be growing? How much control do you have over what's added to the collection? Are available time and available finances factors to consider? How much of a financial difference will better organization make in marketing your work, if that's one of your goals? These questions should help you determine the physical arrangement of the material, the level of detail required in cataloging (if you determine that something more than a self-indexing file is necessary), and the types of supporting files, such as circulation records, that you need to keep. Look at what you'd like to have—and what you really need.

Perhaps as I've been going through the various tools that will help you in cataloging material, you've been mentally totalling up the tab. Remember that you don't have to get everything at once. However, even if you do start with copies of AACR2, the LCSH list and the LC subject cataloging manual—which I'd suggest as the most basic starter set—you'll be spending

less than the cost of most lenses, camera bodies, or even professional-quality flash units. In the long run, these can be just as important to the successful presentation of your collection—however that collection is used.

You don't have to have a computer to get sophisticated access to your collection—but, if you do want sophisticated access by computer, you'll need a sophisticated computer and equally sophisticated software. If you do decide to go the computer route right from the beginning—again, it's always possible to convert manual files at a later date—then get some outside advice, even if you already know something about computers.

If at all possible, talk to someone who has experience with both computers and library applications. The early history of library automation—really only about a decade or so back—contains numerous examples of companies that had successfully produced computer-inventory systems for factories but which then ran into trouble trying to translate that experience to library automation. Remember that libraries are in the business of giving away information. Most librarians will be glad to answer technical questions about cataloging.

Take a look at a directory of picture collections, such as the latest edition of *Picture Sources* (available at most larger libraries) and check the geographic listings for picture collections in your area. Many larger libraries and museums have some types of picture libraries, though they may not always be called that. Ask if they do. And then ask if you can take a look at how things are arranged.

There are a variety of organizations active in the picture library field. They're discussed in the final chapter with addresses listed in an appendix. Many of these offer programs that include tours of picture libraries.

Even after about a decade of treating my picture collection as a library, I still pick up ideas from time to time that help me fine-tune my approach to organizing my materials. That doesn't mean that everything I see others doing will necessarily be right for my collection. The perfect library hasn't been invented yet, and the means of recording and storing information—even just visual information—keep changing. In the end, the real test is to ask whether you can say, as a certain character in a TV series, "It works for me."

ANALYZING AND BUILDING

YOUR COLLECTION

Developing Your Strengths to Create
More Than a File

By now, probably, you've realized that to accomplish some of the things you want—to get that instant retrievability—you'll need to go to quite a bit of trouble. Cataloging requires a continuing investment in time for as long as your collection grows—and this is in addition to the investment required for reference tools, card catalog cabinets, transparency or negative files, and just plain office supplies. You've probably asked yourself, "Why go to all this trouble? How can I possibly compete with the large stock photo agencies with millions of images in their files?" The answer is that you can't—and that you can. It all depends on how you're trying to compete.

Up to this point I've used both the words "file" and "collection"; the two are not interchangeable. A collection is a file developed with a specific purpose and scope.

Large libraries have special departments charged with collection development. This staff constantly assesses the strengths and weaknesses of the collection and how well the collection is serving its intended purpose. For a corporate library, this purpose may be supporting the technical and legal reference needs of the corporation's employees. For a college library, a major aim is to support the educational needs of the institution, particularly to provide literature for the courses taught there. Tax-supported public libraries try harder to be all things to all people and usually have a greater emphasis on pleasure reading.

In short, a library's collection reflects the needs of its patrons—or those of its intended patrons. Keep this in mind when comparing the operation of the large stock photo agencies with the opportunities for stock sales by small photo businesses (or for that matter the opportunities for stock photo placement by small public relations operations).

SUBJECT FOCUS

Take my transparency file, for instance. It contains some 20,000+ 35mm images and has an annual growth rate of about 1,000 to 1,500 slides. My file may be perhaps one per cent the size of even a moderate-size New York based agency. Yet, I've managed stock photo sales to national publications (periodicals, textbooks and encyclopedias, among others).

That's because a substantial portion of my stock sales have been in the areas of railroads and rail transportation. In fact, about one third of my transparency file—some 6,000+ transparencies—represent railroad subjects. Some of the transparencies were made on assignment or to illustrate a specific article I was working on; most, however, were shot simply for the file. About the same time I began full cataloging of my slides, I took careful stock of what I already had and made a conscientious decision to try to develop a balanced collection of images of railroad subjects. This collection development assessment wasn't a one-time thing. It's a continuing process. I'd already written and illustrated articles on the subject when I first began. At that point, however, most of my photos were of a few types of equipment, particularly locomotives.

Locomotives represent only a small part of what railroads are all about. I began trying to shoot more pictures of people involved in railroading, and of other types of equipment and activities: signals, track maintenance, car repair shops, and so on.

Today if someone wants a picture of almost anything related to railroading—a particular type of coupler, computers used in the classification of freight cars at a yard, damage to track caused by locomotive wheel slip, and even wildflowers growing between the ties on a little-used siding—there's a good chance I'll be able to supply it.

A large stock photo agency would also be able to supply railroad photos. Stock photo agencies aim their sales efforts at general purpose book and periodical publishing houses. An encyclopedia publisher may need two or three photos to illustrate a brief article on railroads, and the stock photo agency would be able to provide them.

These agencies, however, are somewhat comparable to public libraries in that they try to be all things to all people—trying to provide at least some subject coverage of all possible subjects. A large part of their collections is devoted to attempting to provide geographic coverage of as many places worldwide as possible.

The idea of such an agency (and remember we're still talking about the very large general-purpose agencies) trying to have some subject coverage of at least 100,000 subjects isn't that inconceivable. Divide a collection of about 1,000,000 images by that number of subjects, even granting that any one image may represent several subjects, and you immediately see that for many subjects the agency isn't going to have even a thousand images.

Which means that with my 6,000+ images on the subject of railroads, chances are already that I have several times more images—and probably more diverse images—than the typical stock photo agency.

Moreover, more than a dozen national periodicals in the United States alone are either devoted entirely to railroading or devote a major part of their space to this subject as part of their coverage of the transportation industry. Some of these publications are aimed at the management staffs of railroads, others at railroad enthusiasts, and still others at shippers who use railroads. The important thing is that they are all highly specialized publications. For them, just any picture of railroads is not going to do. They are going to be looking for very specific images to illustrate articles on particular equipment or processes.

Their editors aren't going to have the time to explain to a stock photo agency's picture librarian what a type E coupler looks like, or what a BQ23–7 is. (It's a special type of diesel locomotive manufactured by General Electric.) Chances are, the general-purpose agency isn't going to have those images anyway.

One thing you learn very early in attempting to organize your own collection is that no matter what type of indexing or cataloging system you use, you can't possibly index for everything that's contained in every image. Even with my specialized collection, I don't index for such things as coupler or locomotive types (though there are exceptions for special categories of locomotives). Yet, I can still supply you with specific images in those areas. That comes from knowing the collection and being able to use other access points to find the desired image. For instance, I know that a particular railroad company owns a specific type of equipment, and that I photographed some of that line's locomotives at its engine facility in a particular city. My slides are cataloged by railroad line and location, so I can get at the desired image that way.

And if I don't know offhand what a particular locomotive or coupler looks like, I have reference books that help. In fact, the one reference book that I use most often to check on locomotive types has one of my own photos on the cover. The publisher needed a photo of a BQ23–7, and I was able to supply it. What I offer these specialized publications is not just a specialized photo collection, but also subject expertise. Every collection needs someone with that.

CULTIVATING SPECIAL MARKETS

There are literally thousands of subject specialties. You can find some of them by looking through the books that list photo markets, but the really specialized markets, including some of the ones to which I've sold stock photos, you won't find there.

These publications concertedly avoid getting into these general market listings because they haven't got time to fool with photographers who don't have a very strong subject background or who don't really have what they need anyway. But you may already know of some of these potential markets because you subscribe to the publications.

Study these publications and look not only at the types of pictures they are publishing now, but also at the types of pictures they might have a use for. What types of text pieces are they publishing without illustrations? What do you have now in your collection—or could you add to your collection—that would fill a specialized periodical's needs.

Periodicals aren't the only area in which you could find a market for a subject specialty. Book publishers, too, often concentrate on specific subject areas. Then there are producers of audio-visual presentations and trade associations that promote the products of a particular industry.

Obviously, the best areas to start with are those in which you already have some images—possibly ones shot on assignment—and in which you can offer potential buyers something others can't. But what if you're not an expert in anything at the moment, and your photographic collection is starting almost from zero? Well, no one is born an expert. All knowledge and experience is accumulated gradually.

If nothing else, you can begin with offering better geographic coverage of your region than someone who doesn't live there. After all, who would have better pictures of the significant features of Outer Podunk—at all times of the year—than someone who lives there?

Every state uses geographic and history textbooks, and these have to get their illustrations from somewhere. So do publishers of encyclopedias which try to cover all areas of the world. But here, too, you need some careful planning and some real work at collection development. It's a well-known fact that tourists often see more and make better photos of a place than people who live there. For the residents, it's too easy to just say that something is always there—and that you can always shoot a subject when the need comes up. Well, yes and no—and, in a surprising number of cases, you'll find that it isn't really so.

If you're really going to try to market stock photos, you'll find that in many cases, the potential buyer is twenty seconds from a publication deadline and would have been much better off if he had had the illustra-

tions yesterday. Even if you are able to do your own color processing (a debatable use of a photographer's time and allocation of his resources), would you be free to shoot the subject the day the request comes in? Would you have time just then for the processing? Would the weather be cooperative that day?

Many subjects are seasonal, and the large publications work on a multi-month lead time. A travel magazine may be working on its fall theme issue in late spring and looking for snow pictures for a December cover in late summer. Even publications with smaller lead times may be looking for photos showing the same subject during a variety of seasons. If someone were looking for illustrations of the predominant agricultural or industrial activity in your area, would you be able to supply them?

This doesn't mean that you should drop everything to build your file—especially if you don't have an immediate prospect for sales of a particular subject. Collection development is largely a matter of setting some general goals and then filling in the gaps. Mostly it's a matter of filling in gaps, and looking for possibilities—not only for sales, but also for building the collection without going too far out of your way. What can you use that unexposed half-roll at the end of an assignment for? What's on the way to or back from some place you're headed for? What can a few hours between assignments be used for?

Many of the subjects that have helped expand the coverage of my collection have come from those left-over frames at the ends of films that would have been developed blank—because I needed the main subject on the film. It costs the same to process a partly exposed roll of transparency film as a fully exposed one. So, those extra subjects for the file were in effect free.

A collection development policy should not only be positive but also negative. You should also have some general guidelines, even if only mental ones, as to the types of images which you do not intend to keep. Do you keep all properly exposed images? What about the case of identical or nearly identical original images? How many you decide to keep will depend on your goals—and the space you have for expansion.

Some gaps in collections are easier to fill than others, but if you get to the point of offering complete coverage of a particular subject, you had better make sure that at least the most obvious areas of the subject are covered—even if it means going out of your way to get the necessary images. After a few unsuccessful requests, your potential buyer is going to look elsewhere the next time. Having a specific collection-development policy and being able to state that to the potential users of your images will diminish unlikely requests and in the long run keep both you and your clients a lot happier. Besides, it's a lot easier to be proud of a collection than just a file.

MARKETING YOUR

COLLECTION

After All, We're Organizing for Visibility

Build a better mousetrap and the world will beat a path to your door? Well, perhaps—if you know how to publicize that mousetrap. The mere fact that you have or are able to make high quality photographs—even that you have your photographs well organized—doesn't guarantee that you will be able to sell publications rights for those photographs.

Photography, for those who make money from it, consists of three equally important parts: science, art, and business. By science I mean some basic understanding of physics and chemistry in the form of what lenses do to light and how chemicals transform latent images into viewable pictures. Art, I define as the sum of the mental processes that determines the content of those images. It consists of composition, cropping, use of color (or black and white tonal ranges) and lots of other ingredients, some of which don't even have words to describe them. Business, which may appear to be the easiest to define of the three, takes at least as much effort, talent and ingenuity as the other two. It's probably the most neglected aspect among beginning photographers who are trying to sell their work.

We've all seen work published in magazines and books, and said to ourselves, "I could have done that," or even, "I could have done much better than that." So why did that particular photographer's work get

used? Probably because he was a better businessperson than the other photographers who could produce images of equal technical and artistic content.

Among my friends and acquaintances are quite a few whom I consider excellent photographers. Most have never sold an image, either because they're not interested in making the effort required of marketing, or don't want to photograph subjects that others are willing to pay for. There's nothing inherently wrong with not wanting to sell your photography. If you're happy doing something that pleases only you, good for you. However, don't complain about the fact that someone isn't willing to buy your work if you haven't made an effort to understand what the buyer wants or needs. Business transactions consist of two parties—and an exchange in which each is getting something of value. For the one party it may be a service or a product; for the other, it's usually money.

UNDERSTANDING THE MARKET
Knowing that I've been involved with photography for much of my life and have even made some money with it, people sometimes ask me what I think of a particular image they've produced. Usually they're more than

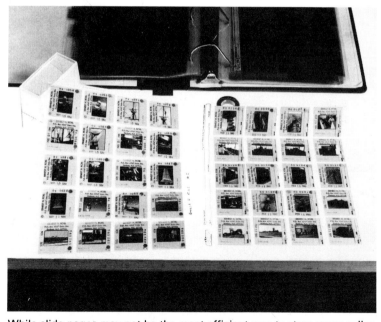

While slide pages may not be the most efficient way to store many collections in terms of space consumed and ease of retrieval, most publications prefer slides to be submitted in this format. Slide pages allow quick review of material in an organized presentation, because they group related images together. Though it's difficult to see here, a semi-rigid page like the one at the left is easier to handle than the soft type at the right. The former usually requires some additional protection for individual slides.

a little startled when I respond to their question with a question of my own, "In what context?"

There's no such thing as a good picture. By saying that I'm not trying to detract from anyone's talent or efforts. All I'm saying is that to judge the "quality" of a picture, you have to know something about the reason it was made and the intended audience.

You have every right to make any kind of photographs you want. But if you insist on making a particular type of photograph and expect to get money for it, particularly from stock photo sales, then you also need to understand the potential market for what it is you are offering. And, sometimes that includes much more than the image itself. In fact, the "quality" of the image may not even be the determining factor in making the sale.

It is possible for an individual photographer or small agency out in the boondocks to compete with the large stock photo businesses in the major cities—because you're able to provide a different kind of service. And "service" is the key word here.

I'll let you in on a secret. It's even possible to compete with organizations that are giving away pictures for free. Think about it. Most states have travel and tourism agencies which will supply photographs to publications for free; most large corporations have public relations departments which will do the same. So why will book and magazine publishers pay for use of an image when they could get something similar free? Certainly the people who work as picture researchers for the major publishing houses aren't stupid; they're well aware of these free sources. Neither do their employers have so much money that they can afford to waste it.

The answer then is that what these potential clients are buying is more than an image; it's a service. You're not just providing a product; you're providing a solution to a problem—though that solution may be in the form of supplying a tangible item, such as a photograph or slide. That service/solution however also includes such additional factors as how quickly you can supply what's needed, the type of selection you provide, how much related information (captions, etc.) you deliver, and how reliable that information is.

If time is a factor, then the researcher will go with the source that can deliver the quickest, regardless of the cost. About half my submissions go out by Express Mail. At a minimum, that means that I've invested about $12 in postage that I have no absolute guarantee I'll make back in the form of a sale of rights. Often, they're submissions going out within less than 24 hours of the time I got the request. Although I haven't done much research in this area, I'd hazard a guess that most corporate or

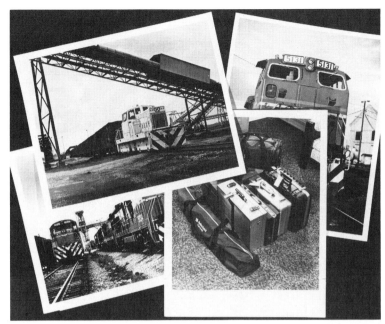

Standardizing print size wherever possible—and cropping borders when a different image shape is desired—greatly simplifies handling and storage. Though some publications will accept smaller prints, I now print everything on 8 x 10 paper unless a client specifically requests otherwise. It is important to leave white borders for the client's instructions to the printer and cropping marks.

government PR departments don't provide that kind of turnaround. I know that some government picture libraries that supply images for nominal print or duplication fees have a several-week backlog of requests.

The service that an individual photographer or agency can provide may also include supplying a diverse group of subjects that a client needs all at once, in response to a single phone call, letter or electronic mail message, rather than requiring the researcher to contact half a dozen sources. Or, the client may feel that the photographer or agency has less of an axe to grind or propaganda value to get across than one of the "free" sources. Ask the XYZ Widget Manufacturing Corp. for a picture of a widget, and they'll probably give you one—one that's photographed to prominently show the XYZ logo on it. An individual photographer or agency wouldn't have that concern, and may even be able to supply pictures of widgets made by several different companies.

Most of the picture editors I've talked with tell me that they will normally turn first to the source they consider to be the one most likely to have the material they want. And, to have them contact you, they have to know that you exist and that you have the material they want.

Ah, yes. That brings up one of the catch-22s of picture marketing. Most potential clients will not contact you to request stock photos unless they've seen some of your images. And, you never, ever, want to send out unsolicited images, because the recipient has no legal responsibility for them and there's no guarantee that you'll ever get them back.

SOLICITING WORK

If you live within easy traveling distance of some potential clients, you can make an appointment to show your portfolio. But, for many of your potential clients, the most economical means of contacting them may well be by mail. Even local clients will want to keep something in their files to remind themselves of what you can do.

It is, of course, possible to have promotional material, showing a few sample images, printed up. Resumes and subject lists aren't that difficult to produce and get duplicated. They may, however, be a bit on the thin side if you're just starting in the stock photo business. Four-color printing, on the other hand, can be very expensive. A thousand copies of a single-sided sheet of four color printing can easily run around $500—in printing costs alone. And that's not counting mailing costs, and the time it takes to produce the mailing list.

Promotional material sent to potential clients should include some indication of the types of images you have to offer, but full-color, promotional "catalog sheets" such as these can be relatively expensive.

How do you get started on getting the word out if you can't make that kind of an investment right away? One way is to carefully target your marketing efforts at a handful of markets most likely to be receptive to what it is that you have to offer. In a carefully written query letter, explain what it is that you have to offer in terms of a service that would fulfill the client's needs—after carefully researching those needs—and then ask the picture editor if he or she would be receptive to looking at some samples of your work. Once you have a request for samples, you at least have some legal protection.

One means of getting low-cost promotional material is to first target some markets with lower fee structures, but which will give good display to your work—and which will give you at least a dozen free copies of the published pictures (with credit line!) which you can then use in promotional mailings to other potential clients. While taking nothing away from those who worked very hard to establish the ASMP guidelines for what price ranges various types of photography should command, it's important to realize that not all clients are willing or able to pay those rates—and that sometimes you may be able to get something from a client beyond the actual dollar figure that's on the payment check.

You should be aware, however, of what the going rate is for various types of stock and assignment photography. There are stories of photographers who have actually lost potential business by asking too little; the potential client assumed they were amateurs and decided not to deal with them. In one case I told a magazine that the figure they offered was an insult, since it would not even begin to cover the costs involved in producing the photography, and that they shouldn't bother contacting me again. But, there have also been some jobs that I did either completely on speculation or at a rate below what I or others might normally have charged. In these cases, I knew ahead of time that I would get something else out of doing the work: material for promotional use; access to some area I would not normally be able to get to and which would produce images valuable to balancing out my collection; etc.

Now, I send out promotional mailings at least once a year to several hundred buyers of stock and assignment photography. Though I use my computer to produce these mailings, they're carefully targeted at the various audiences, with several different cover letters within each mailing, and different lists of my specialties included, depending on that particular market's area of interest. There are probably one or two picture editors out there who think that I'm a pain to deal with, but I certainly don't intend that. On the other hand, there are my repeat customers—I must have done something right for them.

While the stock photography business isn't totally unpredictable, I've found that, for a specialized collection like mine, business tends to go

in spurts. Requests cover a wide range, from ones where editors have a very specific image in mind (down to particular horizontal or vertical cropping) to ones where the requestor simply wants anything on a particular subject. Most requests fall somewhere in between, and it takes some judgment to know when the requestor may be interested in something close to the subject requested, if you can't supply the actual image wanted.

Probably the most difficult thing to learn about marketing stock photography—something that ties in directly with collection development—is that a somewhat bland general view of a subject, particularly a travel subject, often has more market potential than an arty detail shot.

Look at it this way—if an editor or art director can use only one shot to say "this is Vienna," he's going to want to use a general view that includes some well-known landmark, not the detail shot of some lesser-known building. That doesn't mean you shouldn't be adding detail shots—just that if you start with the general views you'll have a better chance of making a sale.

Marketing stock photography is well worth a book of its own, and, in fact many have already been written about it. There are three that I particularly recommend, if you're serious about the business end of photography: Two are by the American Society of Magazine Photographers—their *Professional Business Practices in Photography* (latest edition 1982) and their *Stock Photography Handbook;* the third, worth reading several times, is Henry Scanlon's *You Can Sell Your Photos.* Scanlon, head of a major New York stock agency, has many valuable pointers from his own experience—pointers that are applicable whether you're marketing stock directly or through an agency. (All three books are further described in the marketing section of the bibliography at the end of this book.)

If your collection is very specialized, you may be best off marketing your work directly, unless there's an agency with the same subject expertise. However, the advent of Photonet, has opened the door for marketing material through agencies even if you choose not to put your material with an agency—which normally means having the material out of your hands for several years.

CHARGING FEES

Many agencies now post requests for subjects that they cannot fill from their own files on Photonet. If you submit material to the agency in response to such a posting and it makes a sale, it takes its usual cut (usually 50 per cent) of the payment for rights. After all, it did get the material to a client that you didn't know of yourself. You do make a sale that you wouldn't have made. The rest of your material, however, remains

in your own files to market directly—where you can collect the full 100 per cent of all use fees, since, after all, you're also absorbing 100 per cent of the marketing and promotion expenses.

Which brings us to another important point: most publishing markets now pay for use of photography on the same basis whether it's provided from stock or assignment. The determining factor is the page rate, though an assignment will normally include a minimum guarantee (day rate) against possible page rates and compensation for direct expenses, which is paid even if the material is never published. The page rates make sense since the value is in providing a solution to the client's needs—not how those needs are met.

Some clients, new to the area of stock photography, may try to argue that an image from a file is somehow less valuable than one made on assignment. The response to that argument is to point out that it still costs you just as much to make that image as if it had been done on assignment; and, even if it was made on assignment with someone else purchasing only one-time rights, it costs you additional money to organize and store the images. In fact, you're saving the client time by immediately offering him a known product (against the unknown results of having to book an assignment shoot), and he will not be billed for the direct expenses connected with the shoot in addition to the space rates.

In the long run, marketing comes down to studying the needs of the available markets, taking some basic legal precautions (those sample forms with their terms and provisions provided in the ASMP manuals really are important) and not taking rejection personally. In many cases, editors and art directors do not have time to explain why one of your images wasn't selected, though, after you've worked at this business for a while, you'll get to know some who will even offer you helpful suggestions.

Give the client credit for having good intentions, and he or she will generally do the same for you. I've had a client lose an original transparency—and been compensated for it, since I was protected by the terms of the consignment sheet and use agreement. In a couple of cases I've charged (and been paid) holding fees for material out for excessive periods of time (six months to over a year) with no rights being purchased. On the whole, though, I'd much rather charge a client use fees than holding fees. In publishing (and other areas of business that use stock photography), just as in your own life, things don't always work out perfectly. Production plans for a particular issue or book get changed; text pieces for which the stock photography is intended sometimes don't work out; editors may become ill, quit or get fired; and publications, even the big name ones, don't have unlimited funds.

Be reasonable. If your circulation records show material out for more than a reasonable length of time (which will vary with the type of market

Any image that leaves your collection should be clearly marked with owner-ship and copyright protection stamps, as well as some unique identification that sets it apart from other materials. This address also lets you tie the image to a caption sheet and to your circulation records. On transparencies made by other photographers, I clearly indicate the photographer's name.

and other circumstances), send a reminder note. (Mine includes a self-addressed envelope and a form on which the client can check off a variety of possible responses.) If you strictly enforce every provision of your consignment sheet, you may collect some holding fees this time around but lose out on a sale next time—and many times after that.

When you're sending out your resume soliciting other stock or assignment business, people aren't going to be interested in how many places you've collected holding fees from, but rather where your work has been published and what you can offer them this time around. Checks help to pay the bills, but tearsheets provide their own kind of satisfaction.

You'll have to be patient. The stock picture business is one in which it may be weeks after you've mailed your submission before you get a report requesting an invoice for use fees—and then several more weeks before the check finally arrives. In book publishing in particular, it may be several more months before you actually see your work in print.

The only way to assure that checks come in on at least a somewhat regular basis is to keep a lot of images in circulation at the same time. Just because you've spent a day putting together the submission you just mailed is no reason to stop working and wait for news of a big sale. Due to factors over which you have no control, that news may never come, though by doing your homework, you can maximize your chances. Even for a successful stock picture operation, there'll be slow times, but you can use those for promotion so that there'll be busy times again later.

Here is Sydney Harbour, Australia, with the easily recognizable Opera House and Harbour Bridge. "Sydney (Australia)" suffices to retrieve this image.

Jordan Lake, a man-made reservoir in central North Carolina, was named after a U.S. Senator. I took this photograph of it at dusk from a bridge. The question of whether to index the lake under "Jordan Lake," "B. Everett Jordan Lake," or "Everett Jordan Lake" was resolved by using the form on the official N.C. transportation map. Authority sources come in a variety of formats. The image is also accessible under "Sunsets" and "North Carolina—Scenics."

Here is a section of the Blue Ridge Parkway in western North Carolina,
shot through my car windshield. Access to this image is relatively simple
by looking under "Blue Ridge Parkway" in the catalog, and then looking
at the descriptive paragraphs retrieved to find one mentioning snow.

This is the Elizabeth II, a replica of an Elizabethan sailing ship built to
commemorate the 400th anniversary of the arrival of English explorers
and settlers on the North Carolina coast, shown here at Manteo, N.C. This
image has been used for several photo-decor display prints. Subject head-
ings for the group containing this image include the following: 1. Elizabeth
II (Ship). 2. Manteo (N.C.). 3. Raleigh's Roanoke Colonies, 1584–1590—
Anniversaries, etc. The final heading is from the LCSH list with the addition
of the free-float subdivision "Anniversaries, etc."

Though I have no particular interest in tobacco, I once pulled over to the side of a road and shot this field. Tobacco is a very big part of the economy of North Carolina, and I attempt to offer balanced coverage of the state in my files.

This photo of sea oats framing the Hatteras Lighthouse on the North Carolina Outer Banks was used in an encyclopedia to illustrate an article on North Carolina. Some of the subject headings that I assigned to the group containing this image are: 1. Lighthouses—North Carolina. 2. Cape Hatteras (N.C.) 3. North Carolina—Scenics. The final, non-standard heading allows me to retrieve scenic pictures of the entire state for anyone who wants such representative pictures.

Collection development is largely a matter of keeping your eyes open. I photographed this butterfly in the North Carolina mountains while I was waiting at trackside to photograph a train.

Anything that involves seasonal changes, such as these blossoms on the Duke University campus in Durham, N.C., usually can't be photographed on demand at other times of the year. If it's a subject for which you want to offer stock photo coverage, you need to do some planning ahead. Keep a mental list, and at opportune times shoot such subjects when they're in season.

This is my favorite transparency of all those I shot during my military service
in Vietnam. The contrast of cultures embodied in this picture is difficult
to represent in a subject heading. The image is still easy to retrieve, how-
ever, by using the date or place (DaNang).

Some of my military material was becoming dated, which presented a
problem because military bases are a significant part of North Carolina.
Telephoning the public relations office at Ft. Bragg led me to a day of
photographing Special Forces training activities, including this hand-to-
hand combat demonstration.

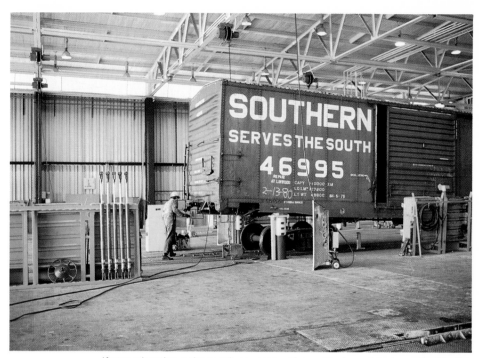

If you advertise a thorough coverage of a particular subject, you had better be able to back it up. This photo is of maintenance work on a boxcar, which represents an important, behind-the-scenes aspect of the railroad industry.

Photos illustrating a concept, rather than just a specific situation, are frequently in demand in the stock photo market. It can be difficult to assign subject headings to concepts. This sunset behind a high-voltage line near my home could be used to illustrate articles on energy, solar energy, electricity, etc. In early spring, I noticed that sunset aligned with the high-voltage line. I waited for a day with the right kind of sky during the two weeks with the correct lighting angle. Subject headings include "Sunsets."

A General Electric BQ23-7 locomotive of the Seaboard Coast Line. This photo, enhanced by late evening lighting that brought out many underframe details, appeared on the cover of a reference book on locomotive types. The publisher wanted a picture of this specific—and, at that time, relatively rare—locomotive. Though I don't index by locomotive type, it was easy to retrieve this image by place, railroad, or chronologically, since I remembered where and when I had photographed it. Even with the best cataloging, there's no substitute for knowing your collection.

Covering the railroad industry is my specialty, and it includes much more than simply displaying trains in attractive, scenic settings. These two crewmen are taking time for a chat during a change of crew on an Amtrak train.

I spotted these rosebushes in bloom while driving through Sanford, N.C. Over a period of about two hours, I shot a variety of trains passing this spot by using a motor on a 35mm SLR. Made purely on speculation, this photo was later sold to the railroad that operates this line, for display in their headquarters in Florida. It's a good example of collection development. Although the bushes and tracks are still there, the blossoms have never again been quite as brilliant. An attractive, generic railroad shot, it has many future sales possibilities.

Since I try to provide in-depth coverage of various aspects of railroads and rail transportation, I frequently go beyond the level of specificity available from the Library of Congress Subject Heading list. For this image of loaded automobile racks being switched at Hamlet, N.C., the subject headings include: 1. Railroads—Freight—Automobiles. 2. Hamlet (N.C.)—Railroads. The first heading adds a third level. The second is also non-standard because it avoids the necessity of creating two headings—one for the town, and another for "Railroads," both subdivided geographically. "Railroads," other than when it includes topical subdivisions, is not a particularly useful heading in my catalog since so much of my material falls into that category.

These are high-speed TGV trains at the Gare de Lyon in Paris. As of the ninth edition of LCSH, the subject heading list did not have a specific heading for these trains, so I made my own: "TGV trains (France)." Additional access is available through headings for Paris and the French National Railways, using the vernacular form (according to AACR2)—"Societé Nationale des Chemains de fer Français."

Duke University's medical center uses this shuttle system to carry patients, staff, and visitors between hospital facilities. This image was used in a textbook, and represents an overlap of two of my specialties—North Carolina and transportation.

COMMON SENSE

A Few Words of Caution and Encouragement, and Some Tips for Success

Organizing pictures, as we've seen, is mostly a matter of being aware of some standards, using a controlled vocabulary with multiple access points for subject retrieval, and mixing in a healthy dose of common sense. You have to think about what you're doing. And, you need to start with the results you want and work backwards from there.

Let me give you an example of using common sense that may not be immediately apparent. I'm sure that you've all seen pictures of film editors or people in processing labs, where these people are wearing thin cotton gloves to protect the film they are handling from fingerprints. In many situations such gloves do make sense—but only if they're changed on a regular basis, with the old ones being either thoroughly washed or discarded. Otherwise, these gloves will simply gradually soak up perspiration (along with its chemical contents which are harmful to film emulsions) and then transfer it to the film emulsion, where, over time, it will still do its damage.

In other situations, the wearing of such gloves may be totally counterproductive. If your collection includes glass plates—negatives or lantern slides—then the minimal protection that these gloves offer is completely offset by the loss of dexterity that they impose. And, if you drop one of these glass-based images and it breaks, it's lost forever.

I stock these cotton gloves, but use them very rarely. The most important precaution you can take before handling photographic images is to thoroughly wash your hands—and to get rid of accumulated perspiration, you may need to do that at regular intervals. Clean white paper makes an excellent work surface and can be discarded after it becomes soiled.

Make it a hard and fast rule never to bring food or drink to the same work surfaces where you're working with images. If you have no other choice than to use a kitchen table, make sure you clean it thoroughly before each work session.

Similarly, binding slides in glass mounts may actually be more of a hazard than a protection to the image. If this thin glass breaks when the slide is dropped, it can cut or scratch the image, causing irreparable damage. Most publications, when they make the color separations for printing, will need to remove the slide from its mount. If it's glass mounted, that just introduces an extra hazard at this stage. Instead, slip the entire slide (including its mount) into a plastic sleeve if it's going to get individual handling.

By the way, make sure that you insist that clients always return any mounts that have been opened, along with the transparency, even if the mount isn't re-usable. Re-mounting the transparency is not a lot of work.

Where slides are going to be handled individually by editors, or when they are being submitted in semi-rigid, open-faced slide pages, you can give the images additional protection by fitting each slide with clear sleeves.

You can get heat-seal mounts from any photo supply store and then seal them with either a regular iron or a tacking iron of the type sold for use in dry-mounting prints. But, when you re-mount the slide, you'll want to transfer all the information from the old mount to the new one. And, that information will also help you clear your circulation records when the item is returned.

PACKAGING

I can't overemphasize the importance of careful packaging for any materials you do send out. By that, I mean packaging that will offer protection to the contents—not packaging that will be difficult for the recipient to open.

Use heavy corrugated cardboard, with at least one sheet on either side of the prints or slide pages (most clients will not want slides in boxes— and sheets will offer far better protection for these images). If you use only one sheet on either side, the corrugation should run at right angles on the two sheets (for instance, side-to-side on the top sheet and up-and-down on the bottom). That will give the package added strength.

Two sheets on either side are even better, giving added protection against puncture damage. I spend considerable time making flip-open cardboard inserts that will fit snugly inside 12 by 15 inch manilla envelopes and that will hold from one to five slide sheets. For smaller numbers of slide sheets, I add in extra cardboard sheets as spacers to keep the material inside from sliding around.

Larger shipments go in corrugated board boxes which have been reinforced by glueing additional sheets of heavy board to all the interior surfaces. On all these containers, I include dayglow orange stickers which say "IMPORTANT. PLEASE save packing materials for return shipment to ERNEST H. ROBL." The stickers—I use several per package; they're not that expensive—include my mailing address, even though it's already on all my slides and prints and also on a return envelope that I include in the package.

I've already mentioned that I send many of my submissions by Express Mail, since most requestors are in a hurry and that will get the item almost anywhere in the continental U.S. within a day. One thing that you may not be aware of is that the Express Mail rates include insurance coverage—if you request it at time of mailing. In addition, I've found that this type of mail does get better handling. So, over-all the slight extra cost is well worth it.

Remember that when you're dealing with clients by mail, the package and its contents will determine the kind of impression that they get of you. Yes, I know that only the quality of the images that you're supplying should count, but in business other things do matter. If you're making a presentation in person, you wouldn't show up in tattered clothes. The

Good organization extends to careful packaging of stock submissions. I make these hinged, corrugated-board sandwiches myself, and add stickers that remind clients to keep this protective packaging for return shipments.

The protective, corrugated enclosures for the slide pages fit snugly inside a 12" x 15½" envelope. A pre-addressed return envelope is always enclosed, even when not specifically requested by a client. Both are prominently stamped to indicate that the contents are photographs. The resulting package gives good protection, is not too difficult to unpack, and makes a good first impression.

164

same goes for your packaging. I've received a number of unsolicited notes complementing me on the way I put my submissions together—indicating to me that a lot of others aren't making the same effort. Where I haven't already had a second inquiry from that client, I'm reasonably sure that I will get another in the future.

You don't need long-winded cover letters, but a short note saying thanks for contacting me can't hurt, and, if applicable, you can mention some new subjects you've added to your files which this client may want to use in the future.

Selling stock photography probably won't bring you vast sums of money and make you rich over night, but it can bring you additional income and a lot of satisfaction even if you're not doing photography full-time. Being able to deliver what you claim you have—on a timely basis—is more important to most clients than who made the image.

CONCLUSION

Where to Go if You Want to Get into Even Deeper Trouble

Librarianship, even for a special area like visual materials, isn't a topic that can be covered comprehensively in a single book. If that were the case, colleges and universities probably wouldn't be offering advanced degrees in the field. All the same, I firmly believe that you don't need to spend a couple of years in an academic setting to be able to understand the basic principles of librarianship.

Throughout this book, I've described published materials and resource people to help you along the way. There's an annotated bibliography following that gives you full citations and a few words about a selection of the more useful sources. Many libraries will be able to offer advice or at least let you look at some of the basic cataloging tools. Other than talking to your local librarian or checking directories for nearby picture libraries or libraries with picture collections, one of the best ways to make contacts in the library community is through library organizations.

LIBRARY ORGANIZATIONS

Sometimes it appears that there are at least as many library associations and library publications as there are librarians. Many of these organizations not only produce newsletters and hold regular meetings, but also sponsor workshops and conferences. Most welcome the participation of all interested people, though they may initially let you join only as an associate or non-voting member if you don't have a full-time library job.

Schools of library science at colleges and universities also frequently hold one- or two-day workshops on specific topics in librarianship, covering such areas as subject access and library computerization. They will almost always take your money for registration at these workshops, regardless of who you are.

Usually, however, the only way to find out about these workshops is through the newsletters and announcements at meetings of local library groups. You can also check which institutions in your area offer curricula in library and/or information science; then, contact the administrative offices of these schools and ask them to put you on their mailing list for announcements of special workshops.

As of late 1985, annual memberships in organizations connected with picture librarianship ranged from $10 for the Visual Resources Association, to $75 for the Picture Division of the Special Libraries Association (SLA). In the latter case, however, it needs to be pointed out that membership cost reflects membership in SLA itself (the Picture Division can be joined only through the parent organization), and includes free subscriptions

Picturescope is a journal devoted to picture librarianship, and is published by the Picture Division of the Special Libraries Association. *Picturescope* reports on both the contents and organization of major picture collections and covers a variety of subjects related to preserving and organizing visual materials in all sorts of collections.

to several SLA publications, discounts on a variety of other publications and on conference registrations, a directory of all SLA members, and other services available from SLA headquarters. SLA does have a permanent headquarters staff, which most of the other organizations don't.

Regardless of the cost of membership, however, it's important to remember that for any of these organizations, the dues do not begin to cover the actual costs of what's offered to the membership, including programs and publications. Much of that work is done with donated time, and the donated use of facilities or equipment (from typewriters to computers) of members or the organizations they work for. You can get much from these organizations, but you also have to be willing to contribute something beyond the check for the dues. I've made valuable friendships through all the organizations I've been involved with in the past few years, especially in the Picture Division of SLA, since I've attended more of that organization's meetings and been more involved in its operations. I've also learned a lot from other members.

At the annual SLA conferences, which I've been attending since 1982, I've learned at least as much from informal conversations at lunch or dinner as from the formal talks listed in the official program. Through these organizations—again primarily SLA's Picture Division—I've met or at least talked by telephone with people ranging from the heads of the Time-Life Picture Collection to picture librarians of major Hollywood film studios. One of the most impressive demonstrations of image retrieval I've ever seen was during a tour of the Time-Life Picture Collection, when the staff was able to locate within about five minutes a print of one of my photos that had appeared in LIFE more than 15 years earlier.

Some organizations, such as the American Society of Picture Professionals (ASPP), emphasize the business aspect of picture librarianship more than others, but the point of attending meetings—except for special programs specifically aimed at getting picture buyers and suppliers together—is not necessarily to hit on every other member who may be a potential client. Rather, these meetings offer a chance to talk about current business practices in a non-threatening situation. Here you can ask a picture buyer, "What are you paying for a quarter-page picture these days?" and get an honest answer.

Even if your collection doesn't neatly fit into a category usually represented in one of these organizations, there's usually still a lot that can be learned. A marine biologist whom I've spoken with a couple of times on the telephone is working on organizing for the American Fisheries Society a picture collection representing all known types of marine life. The collection will be used primarily for teaching purposes, and will sell duplicate slides to educational and research institutions. How did this marine biologist get some of his basic ideas for organizing and setting

policies for this collection? By purchasing and reading a variety of publications produced by the Visual Resources Association (formerly the Visual Resources Committee of the Mid-America College Art Association).

VRA is primarily an organization of slide librarians from college art departments and art museums. But though the subject matter of VRA-member collections and the collection the marine biologist is working with are quite different, he was able to see many parallels because both types of collections primarily support teaching. Though my own collection isn't in the field of art, I find the $10 VRA dues well worthwhile, since the organization's quarterly newsletters provide reviews of other publications in the field of picture librarianship and many articles of general interest.

I know that as a beginner in the field you won't immediately be able to contribute to these organizations by sharing your knowledge of the field. There are lots of other ways you can help, including getting mailings out—and even asking questions at meetings. Don't be afraid to ask questions. Everybody was new to his field at some point, and even the experienced members still learn from each other.

Okay. So you don't have time to wait to get help by joining one or more organizations. Where do you go for immediate help, if you want to hire someone, either to help you set up a collection or as permanent picture librarian for a business?

HIRING A LIBRARIAN
The answer may be to turn to one of these organizations (again, their addresses are in the following appendix) for recommendations, but first you need to consider exactly what type of help you need. Do you really need a librarian—someone with expertise in the field of librarianship—or do you just need clerical help in filing catalog cards and slides? If it's the latter case, you really don't need a librarian.

You need to be aware that some library organizations and a few major libraries consider only those with a masters degree in library science to be "professional" librarians. Other organizations (including the Library of Congress) will consider either an MLS or "equivalent experience" as entry requirements for "professional" positions. There have always been some people without library degrees working in the so-called "professional" library positions, even at major libraries, but the difficulty of defining what type of experience would qualify one for a professional position and the vast range of the "professional" positions—from cataloging to purely administrative activities—makes this an ongoing controversy.

To further complicate the issue, someone with an MLS but little practical experience—a recent library school graduate—probably will not be able to offer the type of help you need. Library schools tend to be heavy on

theory. Students are offered some choice of electives, but the schools try to give an overview of the entire profession, which means that a recent graduate will have had one or perhaps two courses in cataloging, with a brief introduction to AACR2, LCSH and classification systems. As exercises within that course, the student will have actually cataloged perhaps a dozen items, probably mostly of the printed book variety.

Cataloging, both for those with and without the degree, is usually learned on the job in a larger library. It's a job that involves hundreds of judgment calls for each item cataloged, and being able to make those quickly can only come with experience. Large academic libraries, such as those at major universities, are more likely to be able to supply you with a specialist in a particular area (such as cataloging) as a consultant. Corporate libraries (and there are probably more of these than you realize) would most likely be able to supply a generalist with a good overview of a variety of library operations.

Whether you will be able to find someone with experience in the field of picture librarianship will be mostly determined by where you are located. In the major cities, particularly those that are centers of the publishing trade and therefore have both commercial and non-profit picture collections, the pool of experienced people will be much greater. A major benefit of joining any of the picture librarianship organizations mentioned is that all produce directories, some of which even offer listings of other members by geographic location.

Most chapters of SLA—chapters are the local groups, while divisions are the subject-oriented organization-wide groups, with SLA membership including free membership in one chapter and one division—offer a consultation service to businesses. The first session—a meeting with representatives of the chapter's consultation committee, to analyze the needs of the client business—is usually free. For additional help, the client is then referred to an SLA member with expertise in the area. The fees for this work will be negotiated between the consultant and the client. A call to SLA's headquarters will get you the names and addresses of officers of your local chapter (as well as the current officers of the Picture Division); these chapter officers can then put you in contact with the chapter's consultation committee.

As already mentioned, freelance librarianship is a growing subdivision of the library field. These people do research for businesses both by using existing libraries and by searching computer data bases. They also assist businesses in setting up reference libraries and data management systems. There's a subsection of SLA's Library Management Division—the Library Consultant Section—whose members are listed in the SLA directory (*Who's Who in Special Libraries*), published annually and available at most larger libraries. But I'm not trying to scare you about things being

that complicated. Generally, only businesses with very large collections would really need any outside help.

You should be able to use what's covered in this book to set up a management system for your own collection. You'll need to invest in a few reference tools and possibly do some additional reading to learn about special areas, such as preservation of historic images created by now obsolete photographic processes.

Managing a picture collection—organizing your photographs—isn't an end in itself for most of us. It's something for which there really isn't any alternative if we want those photos to be accessible. I don't think I'd ever give up making photos in order to devote all my time to cataloging someone else's work. I do, however, enjoy the time that I devote to cataloging my own work because it's challenging, and because I see the results of that work—initially in terms of findable images, and ultimately as published pictures.

Part 5

APPENDICES

ORGANIZATIONS IN
PICTURE LIBRARIANSHIP
Useful Addresses

The following are some of the major organizations connected with the field of picture librarianship and the marketing of stock photography. If you are interested in joining or getting in touch with area members, contact the organization's headquarters below.

AMERICAN LIBRARY ASSOCIATION

ALA is the largest North American library organization, with many sub-units addressing special aspects of librarianship. It does not, however, currently have any sub-unit addressing picture librarianship.

It's listed here primarily because in the library field, it's one of the major publishers of journals and books, including the *Anglo-American Cataloging Rules* and the *ALA Filing Rules.* It's monthly journal, *American Libraries* (supplied free to members and available at most libraries), is an excellent source for finding addresses of vendors of library supplies. Many local library groups maintain ties with ALA. Write for a catalog of current publications.

American Library Association
50 East Huron St.
Chicago, IL 60611

AMERICAN SOCIETY OF PICTURE PROFESSIONALS

ASPP is an organization of photographers, picture researchers, picture editors, archivists and picture librarians, that emphasizes the business and legal aspects of picture use, primarily for publication, but also for some other commercial purposes.

It publishes a directory (approximately every two years, available to members only), a newsletter (somewhat irregular appearances in 1985, with a change in format being considered), and also distributes announcements of local meetings and other events of interest to people in the picture business.

ASPP sponsors an annual photo show in New York in October designed to let picture suppliers and consumers get together. ASPP has chapters in the following areas:

New York
New England (Boston)
Chicago
Washington, D.C.
West Coast (San Francisco)

The headquarters address is:

American Society of Picture Professionals
P.O. Box 5253
Grand Central Station
New York, NY 10163

SOCIETY OF AMERICAN ARCHIVISTS

SAA is a group interested primarily in historical collections though many of these collections are also acquiring contemporary materials.

Society of American Archvisits
600 S. Federal St., Suite 504
Chicago, IL 60606

SPECIAL LIBRARIES ASSOCIATION PICTURE DIVISION

The Picture Division is a relatively small unit (approximately 200 members) within the much larger association (approximately 12,000 members), with membership only available by joining the parent organization.

Membership in SLA includes membership in one division (subject interest group) and one chapter (local area group), subscriptions to the quarterly journal *Special Libraries*, the monthly bulletin, *Specialist*, as well as newsletters of the chapter(s) and division(s) selected. Effective 1986, the organization-wide membership directory will be supplied free to all members as an issue of *Special Libraries*. SLA also publishes a variety of books and journals in librarianship and related fields.

The Picture Division presents programs (panels, visits to picture collections, etc.) at the SLA annual conference in June of each year and publishes the journal *Picturescope,* available to both members and non-members by subscription only. Members get a discount. See the description in the following bibliography.

Though the interests of this organization overlap somewhat with those of ASPP (and the two have at times cooperated on projects), the Picture Division's emphasis is more on the organization of collections and the technology available to picture librarians. SLA moved its headquarters from New York to Washington in August of 1985:

> Special Libraries Association
> 1700 18th St. NW
> Washington, DC 20009

VISUAL RESOURCES ASSOCIATION

VRA, which began life as the Visual Resources Committee of the Mid-America College Arts Association, is primarily an association of art-slide librarians (approximately 550) employed by art museums and college art departments.

It produces a membership directory (with geographic index), holds an annual conference, and publishes as quarterly journal, the *International Bulletin for Photographic Documentation of the Visual Arts,* supplied free to members, which covers not only organization of slide collections but also photography of art objects. Also, it publishes a variety of booklets on special aspects of slide library management. For membership information, write:

> Visual Resources Association
> c/o History of Art Department
> Tappan Hall
> University of Michigan
> Ann Arbor, MI 48109

GLOSSARY

How to Speak "Library" in One Easy Lesson

This glossory provides a quick overview of library terminology—particularly in areas that relate to the organization of images. For terms identified with an asterisk (*), the definition is based on that in the (much more extensive) glossary of the *Anglo-American Cataloging Rules,* 2nd ed. (AACR2). In other definitions, the abbreviation LCSH refers to the Library of Congress Subject Heading system.

Since usage of some special purpose terminology may vary from one work to another, check for glossaries in other works that you may consult. In the following bibliography, an indication is made of which works contain their own glossaries.

* *Access point.* A name, term, code, etc., under which a bibliographic record may be searched and identified. See also *Heading.*
* *Added entry.* An entry, additional to the main entry, by which an item is represented in a catalog; a secondary entry. See also *Main entry.*
* *Catalog.* 1. A list of library materials contained in a collection, a library, or a group of libraries, arranged according to some definite plan. 2. In a wider sense, a list of materials prepared for a particular purpose, e.g., an exhibition catalog, a sales catalog.

* *Conventional name.* A name, other than the real or official name, by which a corporate body, place, or thing has come to be known.

* *Corporate body.* An organization or group of persons that is identified by a particular name and that acts, or may act, as an entity. Typical examples of corporate bodies are associations, institutions, business firms, nonprofit enterprises, governments, government agencies, religious bodies, local churches, and conferences.

* *Cross-reference.* See *See reference.*

Dictionary catalog. Catalog in which all entries (author, title, subject, etc.) and their references are interfiled in one alphabetical sequence; the opposite case usually consists of having two alphabetical sequences—one for author-title headings, the other for subject headings.

Direct subdivision. In LCSH practice, geographic subdivision of subject headings by name of a local place without interposition of a larger geographic entity. Now used only in certain special situations. See also *Indirect subdivision.* Example: Public sculpture—Washington (D.C.)

Downward reference. In LCSH practice, a reference from a broad term to a narrower one.

Explanatory reference. A reference providing statements about the heading involved; used when simple *"see"* or *"see also"* references do not give adequate guidance to the user of the catalog.

Form heading. In LCSH practice, a heading presenting the physical, bibliographic, artistic or literary form of a work. Example: Aerial photographs.

Form subdivision. In LCSH practice, a division of a subject heading which brings out the form of the work. Example: Contour farming—Aerial photographs.

Free-floating subdivision. In LCSH practice, a subdivision which may be used by a cataloger under any existing heading for which it makes sense—without that heading having to be specifically authorized in the LCSH list.

Geographic qualifier. The name of a larger geographic entity added to a local place name to distinguish it from other local place names which would otherwise be identical. Examples: Durham (N.C.); Durham (N.H.) For entities with governments, the forms of the qualifiers are determined by AACR2; for geographic features, LCSH rules generally parallel those of AACR2.

Geographic subdivision. In LCSH practice, a subdivision by place name showing the limitation of the application of the main heading. See also *Direct subdivision; Indirect subdivision.*

* *Heading.* A name, word, or phrase placed at the head of a catalog entry to provide an access point in the catalog.

Indirect subdivision. In LCSH practice, geographic subdivision of subject headings by name of country, constituent country (Great Britain), state (United States), province (Canada), or constituent republic (USSR) with further subdivision by name of state (other than United States), province (other than Canada), county, city, or other locality. Example: Telecommuting—Virginia—Richmond.

* *Main entry.* The complete catalog record of an item, presented in the form by which the entity is to be uniformly identified and cited. The main entry may include the tracings of all other headings under which the record is to be represented in the catalog. See also *Added entry.*

Pattern heading. In LCSH practice, a heading which serves as a model of subdivisions for headings in the same category. Examples: Shakespeare, William, 1564–1616, as a model heading for literary authors; Piano, as a model heading for musical instruments. Also called "Model heading."

* *Predominant name.* The name or form of name of a person or corporate body that appears most frequently (1) in the person's works or works issued by the corporate body; or (2) in reference sources, in that order of preference.

Qualifier. In LCSH practice, a term (enclosed in parentheses) placed after a heading for the purpose of distinguishing between homographs or clarifying the meaning of the heading. Examples: PL/I (Computer program language); Mont Blanc (Freighter). See also *Geographic qualifier.*

* *Reference.* A direction from one heading or entry to another. [Not to be confused with *Added entry.* See also *See reference* and *See also reference.*]

See also reference. A direction from one valid heading to another valid heading under which related material may be cataloged. (Often abbreviated in library literature as "xx-ref.")

See reference. A direction from an alternate or invalid form of heading to the form of heading used as an access point in a catalog. (Often abbreviated in library literature as "x-ref.")

Shelflist. A catalog file arranged by call number (address) order, in which the call number (address) serves as the access point. For

catalogs of picture collections, it is useful for going from an identification number on an item back to the catalog record for further information about the item.

Subject analysis. The process of identifying the intellectual content of a work. The results may be displayed in a catalog through notational symbols as in a classification system, or verbal terms such as subject headings or indexing terms.

Subject heading. In LCSH practice, the term (a word or a group of words) denoting a subject under which all material on that subject is entered in a catalog.

* *Subordinate body.* A corporate body that forms an integral part of a larger body in relation to which it holds an inferior hierarchical rank.

Topical subdivision. In LCSH practice, a subdivision which represents an aspect of the main subject other than form, place, or period. See also *Form subdivision; Geographic subdivision.*

* *Tracing.* 1. The record of the headings under which an item is represented in the catalog. 2. The record of the references that have been made to a name or to the title of an item that is represented in the catalog.

Upward reference. In LCSH practice, a reference from a narrow term to a broader term. See also *Downward reference.*

ANNOTATED
BIBLIOGRAPHY
Other Sources of Information

The following books and periodicals represent just a small
sampling of the many books and periodicals that have some
bearing on the subjects discussed in this book. In many
cases, only parts of the described items have application for someone inter-
ested solely in the organization of pictures.

The items listed were selected mostly on the basis of my having some
familiarity with them; because a particular book isn't included doesn't
mean that it may not offer something of value. Check the subject catalog
of your local library under the headings "Cataloging," "Cataloging of pic-
tures," "Subject cataloging," "Subject headings," and "Libraries—Auto-
mation." Check for see also references sending you to other related subjects.

Many libraries will own some of the basic cataloging tools mentioned
in earlier chapters and listed below, but may not show them in the catalog
of their holdings, since they consider them working tools. Check with a
librarian to see if you can take a look at some of these.

Items that are no longer in print and which you simply want to look
at may be available through inter-library loan from another institution,
if your local library does not have them. For many of the items listed,
the value of the contents will not have become dated over time. Libraries
and bookstores will have copies of *Books in Print,* showing whether newer
editions are available and what the current selling prices are.

Many of the organizations listed in the preceding appendix also publish a variety of newsletters and manuals, only a few of which are listed below. Contact the organizations for their current list of publications.

Punctuation and capitalization in the listings follow the *Anglo-American Cataloging Rules,* 2nd ed.

GENERAL SOURCES

Evans, Hilary. *Picture Librarianship* /Hilary Evans.—New York: K. G. Saur, [1981?] (Outlines of modern librarianship). Bibliography, index.
> *Primarily British point of view, with emphasis on picture collections as part of larger libraries.*

Picture librarianship /edited by Helen P. Harrison.—Phoenix, AZ: Oryx Press, c1981. Bibliography.
> *Collection of essays by various authors on various aspects of picture librarianship. Some essays are more useful than others.*

Wynar, Bohdan S. *Introduction to cataloging and classification* /by Bohdan S. Wynar, with the assistance of Arlene Taylor Dowell and Jeanne Osborn.—6th ed.—Littleton, Colo.: Libraries Unlimited, 1980. Bibliography, indexes, glossary.
> *Not particulary useful for those interested specifically or only in organization of picture collections, but provides a good foundation for those interested in wider issues of librarianship and cataloging of other materials.*

CATALOGING REFERENCE

Anglo-American Cataloging Rules—2nd ed./prepared by the American Library Association, the British Library, the Canadian Committee on Cataloguing, the Library Association, the Library of Congress; edited by Michael Gorman and Paul W. Winkler.—Chicago: American Library Association, 1978. Glossary, index, list of cataloging abbreviations.
> *Available in both paperback and hardbound editions—get the hardbound; it'll last longer. One of basic cataloging tools with rules for description and making name headings. Other editions available from library organizations in other English-speaking countries.*

Chan, Lois Mai. *Library of Congress subject headings: principles and applications* /Lois Mai Chan.—Littleton, Colo.: Libraries Unlimited, 1978. (Research studies in library science). Glossary, bibliography, index; other appendices showing special aspects of LCSH.
> *Now somewhat dated (name heading examples reflect pre-AACR2 practice; LC policies in some areas have changed slightly) but excellent overview to LCSH, particularly its historical development. Somewhat technical. Independently written book by a long-time LC staff member.*

Library of Congress. Subject Cataloging Division. *Library of Congress subject headings* /Subject Cataloging Division, Processing Services.—9th ed.—Washington: Library of Congress, 1980. Brief introduction.

> *The essential list—two volumes, 2,600+ pages. Kept up to date by quarterly supplements cumulated annually. 10th ed. due in 1986. Also available in microfiche issued quarterly. (Slightly outdated fiche discarded by a local library may still be quite useful.) The book edition is well worth getting, however, as it will save you much work in trying to design your own subject headings and provide a ready-made authority structure that can be used with your catalog.*

Library of Congress. Subject Cataloging Division. *Library of Congress subject headings: a guide to subdivision practice* /Subject Cataloging Division, Processing Services.—Washington: Library of Congress, 1981.

> *Basically reproduction of scope notes (definitions and instructions) for use of free-floating subdivisions which originally appeared in the introductory section of the 8th ed. of LCSH (but not included in the 9th ed.!) This material may again be included in the 10th ed.—see preceding listing.*

Library of Congress. Subject Cataloging Division. *Subject cataloging manual* /Subject Cataloging Division, Processing Services.—Preliminary ed.—Washington: Library of Congress, 1984. Index.

> *500+ pages in looseleaf form (you supply your own binder or binders), consisting of numbered instructional/policy memos from LC administrators to the staff of the LC Subject Cataloging Division—but with a very useful table of contents and index. Memos cover rules for making headings for geographic features (not capable of authorship, therefore not covered in AACR2!), rules for application of free-floats and patterns in specific subject areas, etc. Extremely useful and a fabulous bargain at $20 (price as of late 1985—subject to change, of course). Some information in this manual is updated by the LC Cataloging Service Bulletin, described below.*

Marshall, Joan K. *On equal terms: a thesaurus for nonsexist indexing and cataloging* /Compiled by Joan K. Marshall.—New York: Neal-Schuman, c1977.

> *Some of the problems in LCSH have since been addressed by LC. Nevertheless, this is worth looking at, particularly if you make your own subject headings in an area not covered by LCSH.*

PRESERVATION

Caring for photographs: display, storage, restoration /by the editors of Time-Life books.—New York: Time-Life Books, c1972. (Life library of photography) Bibliography, index.

Little information on sophisticated methods of organizing images or cataloging, but good introductory material on the three topics in the subtitle: display, storage and restoration. Newer edition available under title Conservation of Photographs.

Ritzenthaler, Mary Lynn. *Archives & manuscripts: administration of photographic collections* /Mary Lynn Ritzenthaler, Gerald J. Munoff, Margery S. Long.—Chicago: Society of American Archivists, 1984. (SAA basic manual series) Glossary, bibliography, index; addresses of suppliers of archival materials, foundations making grants.

Deals extensively with earlier photographic processes and the problems of dealing with their products. Helpful information for administration of non-profit collections; administrative information less useful for commercial operations.

COMPUTERS

Fosdick, Howard. *Computer basics for librarians and information scientists* /Howard Fosdick; with a foreword by F. Wilfrid Lancaster. —Arlington, Va.: Information Resources Press, 1981. Bibliography, indexes.

Not for the beginner starting with his or her first computer. Mostly oriented toward large-scale operations using mainframes. No glossary included.

Grosch, Audrey N. *Minicomputers in libraries* /by Audrey N. Grosch.— White Plains, N.Y.: Knowledge Industry Publications, c1979. (Professional librarian series). Bibliography, indexes.

Aimed at larger operations. However, some of the things formerly possible only on minicomputers are now available on high-end microcomputers.

McGlynn, Daniel R. *Personal computing: home, professional and small business applications* /Daniel R. McGlynn.—New York, Wiley, c1979. Bibliography, index, glossary, lists of computer organizations and computer manufacturers.

Not specifically aimed at library applications, but a somewhat better than average (and slightly more technical than average) introduction to small computers and what they can do.

Rosa, Nicholas. *Small computers for the small businessman* /Nicholas Rosa and Sharon Rosa.—Portland, Or.: Dilithium Press, c1980. Bibliography, index, glossary, technical appendix.

A look at what small computers can (and cannot) do for a small business. Not specifically oriented toward library applications.

Sanders, Norman. *A manager's guide to profitable computers* /Norman Sanders; illustrations by Tony Hart.—New York: Amacom, c1979. Index.

Making business decisions about using computers; not specifically oriented toward either library or photography applications. (By the author of Photographing for Publication.*) A 1985 edition is available under the title* Computer-aided Management.

Simpson, George A. *Microcomputers in library automation* /George A. Simpson.—McLean, Va.: MITRE Corp., 1978. (MITRE technical report; 7938) Bibliographical references, glossary, list of vendors.

Very basic. The final report of a federally sponsored project.

Toohill, Barbara G. *Guide to library automation* /Barbara G. Toohill.—McLean, Va.: Metrek Division, MITRE Corp., 1980. Bibliographies, glossary, vendor list.

Implementation procedures. No specific products are discussed or reviewed.

PERIODICALS (GENERAL LIBRARY)

American libraries.—v. 1– —Chicago: American Library Association, 1970– . Monthly magazine.

Official bulletin of the American Library Association (see address in organization list; supplied free to ALA members). Listed here primarily because most major library suppliers advertise in this publication—a source of addresses to write for catalogs of supplies, etc.

Cataloging service bulletin /Processing Services, Library of Congress.— No. 1– —Washington, D.C.: Library of Congress, 1978– . Quarterly.

Internal LC publication also available to the public: Includes LC AACR2 rule interpretations, subject cataloging policies (including updates to the Subject cataloging *manual mentioned above), etc. Most of the contents will probably not be of much use to administrators of photographic collections; some parts, however, will be extremely useful. Take a look at some copies at a library to see if you should subscribe.*

LJ, Library journal.—New York: Bowker, – Semimonthly (monthly July–Aug.).

Largest independent (not affiliated with any library organization) general library magazine. Listed here primarily because most major library suppliers advertise in this publication—a source of addresses to write for catalogs of supplies, etc.

PERIODICALS (PICTURE LIBRARY)

International bulletin for photographic documentation of the visual arts.—v. 7, no. 1– —Ann Arbor, MI: Visual Resources Association, 1980– . Quarterly. Continues the *Slides and photograph newsletter* of the Mid-America College Art Association.

Supplied free to VRA members. Though primarily aimed at art slide librarians, many of the articles contain information of general applicability to other types of picture collections. Includes reviews and summaries of articles relating to picture librarianship in a variety of other publications. Also includes some articles on photographing works of art.

Picturescope.—v. 1– —Washington: Picture Division, Special Libraries Association, 1953– . Quarterly/irregular.

Though somewhat irregular in recent years due to both financial and staffing (volunteer) problems, subscriptions for a year are honored for four issues. Available by subscription to both members and non-members of the Picture division of SLA. Covers a variety of issues relating to organization, conservation and automation of picture collections. (Note that its address is different from that of SLA headquarters. For information, write: P.O. Box 50119, F St. Sta., Tariff Commission Bldg., Washington, D.C. 20004.)

MARKETING PICTURES

American Society of Magazine Photographers. *Professional business practices in photography 1982: a compilation* /by the American Society of Magazine Photographers.—New York: ASMP, c1981. Glossary, sample forms.

An attempt to standardize business practices for professional photographers and those who purchase their work. Guide to rates paid for various types of work. Revised editions generally appear every four to five years.

American Society of Magazine Photographers. *Stock photography handbook: a compilation* /by the American Society of Magazine Photographers.—New York: ASMP, c1984. Bibliography, glossary, index, sample forms.

An expansion of the stock photography section of the ASMP Guide to business practices. A must-have reference work for anyone marketing stock photography.

Kopelman, Arie. *Selling your photography: the complete marketing, business, and legal guide* /Arie Kopelman and Tad Crawford.—New York: St Martin's Press, c1980. Bibliography, index, list of organizations.
Straightforward guide to the business aspects of photography.

Miller, Gary. *Freelance photography* /by Gary Miller.—Los Angeles, Calif.: Petersen Publishing Co., c1975.
Readable introduction to business of freelance photography.

Photographer's market.—Cincinnati, OH: Writer's Digest Books, 1978– . Annual. Bibliographies, index, glossary.

Published in fall of year preceding cover date (in other words, 1987 issue would be available in October of 1986). Lists several thousand markets for stock and assignment photography along with descriptions of their needs, specifications, and rates paid. Not all of these markets pay rates from which you can make a reasonable profit.

Photographer's market newsletter.—v. 1, no. 1– —Cincinnati, OH: F & W Pub. Co., c1981– . Monthly.

Supplements and updates the annual listed above. Also contains articles on promotion and marketing various types of photography.

Scanlon, Henry. *You can sell your photos: a comprehensive, easy-to-understand guide for amateur and professional photographers*/by Henry Scanlon.—New York: Harper & Row, 1980. Index, stock agency list.

Excellent overview of the stock photography business by the head of a major stock photo agency.

Schwarz, Ted. *How to start a professional photography business.* Ted Schwarz. — Chicago: H. Regnery, c1976. Bibliographical references, index.

Overview of business aspects of photography with emphasis on starting a business. Also available in other editions from other publishers.

PICTURE RESEARCH

Evans, Hilary. *The art of picture research: a guide to the current practice, procedure, techniques and resources*/Hilary Evans.—Newton Abbott [Eng.]; North Pomfret, Vt.: David & Charles, c1979. Bibliography, glossary, directory of organizations, index.

Primarily from a British viewpoint but the most comprehensive book on the subject. Useful to photo suppliers since it shows the other side of the fence.

Robl, Ernest H. *Picture Sources.* —4[th ed.]/edited by Ernest H. Robl.— New York: Special Libraries Association, 1983. Indexes (subject, geographic, collection name).

No, this is not a tool for finding where to sell your pictures, though it does list major stock photo agencies, but rather a directory showing what other picture collections offer. The geographic index can help you locate picture collections in your area, both commercial and non-commercial, which you may be able to visit to see how they have organized their materials.

INDEX